# NEW ART from the SOVIET UNION

# NEW ART from the

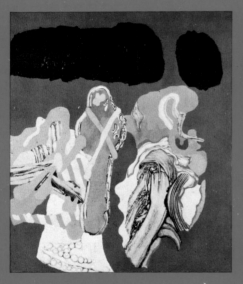 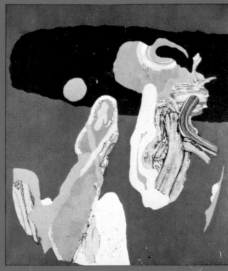 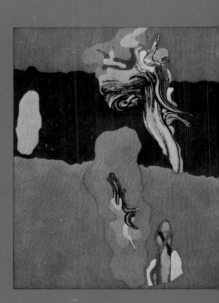

A

# SOVIET UNION

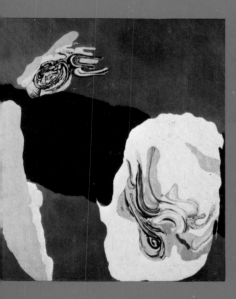
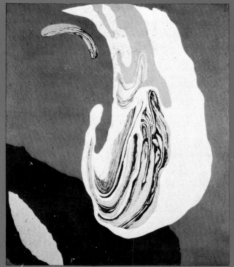

## The Known and the Unknown

Norton Dodge &
Alison Hilton

PUBLISHED BY **ACROPOLIS BOOKS LTD.** • WASHINGTON, D.C. 20009

First published in the United States by
Acropolis Books Ltd.
Colortone Building, 2400 17th St., N.W.
Washington, D.C. 20009

in collaboration with
The Cremona Foundation, Inc.
Mechanicsville, Maryland 20659

with encouragement and support from
The Research and Development Committee
American Association for the
Advancement of Slavic Studies

Printed in the United States by
Colortone Press, Creative Graphics Inc.
Washington, D.C. 20009

Library of Congress Catalog Card No.: 77-13442
ISBN: 87491-209-1

**Yuri Dyshlenko**

Untitled
Series of five 1975
Oil on canvas
75 x 60 cm. each

# Contents

7    Preface

9    Introduction    Alison Hilton and Norton Dodge

20    Moscow: The Contemporary Art Scene
           John E. Bowlt

27    Two Decades of Unofficial Art in Leningrad
           Constantine Kuzminsky

31    The Avant-Garde in Soviet Estonia
           Stephen C. Feinstein

35    From the Real to the Surreal    Janet Kennedy

40    Nonobjective Art: The Container is the
       Thing Contained    Sarah P. Burke

44    Conceptual and Pop Art    Norton Dodge

50    The Future of Soviet Art    Igor Golomstock

55    Illustrations

125    List of Artists

126    Bibliography

# Preface

This book and the exhibition *New Art from the Soviet Union: The Known and the Unknown* were prepared concurrently and with the same purpose: to present the most interesting work from the Soviet Union to a Western audience in a fuller way than has been possible until now. The works are primarily by unofficial artists, but the works of some official artists are included, particularly from the Baltic area where artists have greater latitude.

The scope of the exhibition is unavoidably circumscribed by the availability of the paintings. Some areas of the Soviet Union where interesting new developments are occurring, such as the Georgian and Armenian Republics, could not be represented. As a result, our focus is on three major centers of artistic development: Moscow, Leningrad, and the Baltic area.

Assembling the collection of works upon which the exhibition is based and the archive of documentary materials, including the artists' statements, biographies, and exhibition records, has taken several years. The impetus for the actual publication and mounting of the exhibition came from a combination of related factors. In the West, increasing concern for the urgent problems of non-conformist Soviet artists and intellectuals is accompanied by a growing awareness of the artistic significance of their work. At the same time, many artists have been realizing the need for an international audience, not only for the protective value of world opinion but also for the sake of their own growth as artists. As the following chapters indicate, a number of the ablest unofficial artists have emigrated or are considering emigration from the Soviet Union. They have a particular interest in the reception of their work in the West.

The present level of interest in the West is evidenced by the number of recent articles on unofficial Soviet art in the general press and in art periodicals. Several exhibitions were mounted in Europe by Alexander Glezer (founder of the Russian Museum in Exile, Montgeron, France) and the emigre artist Mikhail Shemyakin. Last year the major exhibition, *Unofficial Art from the Soviet Union* (London, 1976), organized by Sir Roland Penrose and Michael Scammell with the assistance of Igor Golomstock and Alexander Glezer, received considerable attention.

The primary aim of the book is to treat the varying stylistic and thematic tendencies in the heterogeneous body of art that is labeled "unofficial" with as much attention as is usually given political events on the Soviet art scene. The extremely complicated and continually shifting situation within the Soviet Union is examined from three different vantage points in the chapters by John E. Bowlt, Constantine Kuzminsky, and Igor Golomstock. Chapters by Stephen Feinstein, Janet Kennedy, Sarah Burke, and Norton Dodge discuss the distinctive movement that has emerged in Estonia, the surrealist current in Moscow and Leningrad, nonobjective art and its special forms and philosophical problems, and the recent developments of pop and conceptual art. Other stylistic and thematic elements which affect virtually all the unofficial artists in one way or another are examined in the Introduction. For example, a fundamental antimaterialism may be considered a result of both harsh material conditions and the philosophical positions of some artists. Its corollaries are a tendency toward an analytical conception of works as units in larger series and an apparently contradictory tendency toward an emotional, passionately conservative attitude toward the past.

The authors do not attempt to formulate a definition of unofficial Soviet art because the art itself is continually developing and much of it remains unknown even to the majority of the unapproved artists. The term "unofficial" is used in preference to more polemical ones, such as "dissident" or "underground." It merely means that the art is not acceptable by official Party standards. This term is serviceable because it does not wrongly limit the art in question to any one style or tendency. But it is not descriptive and does little to suggest either the thematic and stylistic diversity, or the artistic quality of officially unrecognized art in the Soviet Union.

The broad scope of this exhibition and book entails obvious difficulties. In general, we tried to give the major tendencies the greatest prominence, while allowing the more complex and tenuous relationships among artists and among specific trends to emerge. Our present level of awareness of what is going on in the Soviet art world is indicated by the fairly representative selection of the work of unofficial artists in this book.

Only a few years ago, our opinions of the quality of unofficial art depended on pitifully few works: exposure to them was almost fortuitous; selection of the best examples of an artist's work was difficult; and anything like a reasonable survey of any artist's output was impossible. While many of the barriers hindering access to Soviet unofficial art still exist, time and the steady work of collectors and scholars and the efforts of the artists themselves have somewhat alleviated the situation. Nevertheless, the major works of many artists remain in their own possession; they can neither be exhibited nor transported. In some cases at least photographs are available, and these absent works can be taken into account.

Neither this book, nor the exhibition, could have been undertaken without the generous efforts and advice of a number of people who cannot be mentioned individually but who have our sincere gratitude. They include both the artists and the collectors who have loaned works for the exhibition or provided essential information about them for the archive (the catalogue does not list individual owners of works). The following people provided inestimable help in obtaining funding, in planning the exhibition and the related conference on unofficial Soviet art, and in arranging practical details connected with the exhibition and publication: Warren Eason, Executive Secretary, American Association for the Advancement of Slavic Studies; William

Zimmerman, Chairman of the Research and Development Committee of the AAASS; Murray Feshbach, President of the Washington D.C. Chapter of the AAASS; S. Frederick Starr, Secretary of the Kennan Institute for Advanced Russian Studies, the Woodrow Wilson Center for International Studies, the Smithsonian Institution; Michael Scammell of the Writers' and Scholars' Educational Trust, London; Alexander Glezer, Director of the Russian Museum in Exile, Montgeron, France; Jonathan Ingersoll, Director, St. Mary's College of Maryland Gallery and Curator, Cremona Foundation; and the directors and staffs of the Arts Club of Washington, the Herbert F. Johnson Museum of Art at Cornell University and the Rowe House Gallery, Jane Haslem Gallery and B. David Galleries in Washington. We are grateful to Alice Baber, Bernard Burt, Janet Solinger, and Frances Switt for their help. We wish also to thank Helen Jakobson and Louise Graves for specific materials; and Rimma Vinnikova for her assistance in translating Professor Golomstock's chapter; Margaret Wallace for French translations; Rosamund Davies for expert editorial assistance; Rosemary Stuart for completing an unusually difficult job of cataloguing works of art, arranging the archives, and help in editing; and Wilber Harman, Rosemary Fallon, and Rosalie Fanale for a variety of assistance.

Above all, the editors thank the scholars who contributed articles to the present book: John Bowlt, University of Texas at Austin; Constantine Kuzminsky, University of Texas at Austin; Stephen Feinstein, University of Wisconsin at River Falls; Janet Kennedy, Indiana University; Sarah Burke, Trinity University; and Igor Golomstock, St. Anthony's College, Oxford. Not only did they cooperate despite a very inconvenient publication schedule, but they also contributed material and suggestions of great value in the Introduction and in other chapters. The enthusiasm of the collaborators and the constant moral encouragement of everyone connected with this project have been of the utmost importance.

It is premature to speak of the completion of this project, which was conceived as a first step toward bringing unofficial art from the Soviet Union to the Western public. Many other artists could be included in subsequent exhibitions, or a smaller group of artists could be shown in greater depth. In addition to what is already available, there is a considerable body of literary material related to unofficial art which should be published. The recent major exhibitions in Paris and London opened the way for the study and criticism of unofficial Soviet art. This exhibition should add to our understanding of an intrinsically valuable body of modern art.

# Introduction

Alison Hilton and Norton Dodge

Art which is not consistent with the requirements of Soviet socialist realism comprises only a small proportion of the nation's artistic output. Because it is inherently individualistic and heterogeneous, unofficial art has a potential for a more diversified and more profound appeal than does socialist realism, which serves political purposes and is directed to an artificial common denominator of Soviet society. Therefore, public exhibition of unofficial art is regarded as a challenge by representatives of official standards in art, and unofficial exhibitions are received with a hostility that seems out of proportion to their real effects.

Significant changes are actually occurring in the Soviet art world, both in official policies and in the attitude of a comparatively large segment of the public toward non-traditional art. They are taking place not as the result of a dialectical struggle between a monolithic cultural authority and a committed revolutionary group, but rather, to a great extent, through the influence of artists and groups of artists who belong neither to the official sphere nor to the actively unofficial groups, but to a hazy area between them. Among them are members of the Union of Artists in cities other than Moscow and Leningrad, where regulations are much more flexible. Many are active in local artists' organizations and exhibit regularly under Union sponsorship. Particularly in the Baltic republics and the Transcaucasus, the administration of the arts seems to permit rather than to thwart experimentation and innovation. Those artists who benefit professionally from such favorable conditions cannot, strictly, be considered unofficial artists since they function within the established cultural structure. However, in purely artistic terms, they are close to many of the unofficial artists; some of their most interesting work is done not for official exhibitions and art salons but for the purpose of developing new aesthetic concepts, new techniques, and new themes that are similar to some of those that absorb their unofficial colleagues. The essential difference between the unofficial artists of Leningrad and Moscow and the artists of Tallinn, Tbilisi, Yerevan, and certain other provincial centers is that the greater the distance from Moscow, the greater the leniency of the local officials toward the artists.

Standards for the ideological content and visual appearance of works of art are officially established, but their application and interpretations may vary widely. This introduction does not attempt to account for the whole range of departures from these norms, but it does seek to provide the historical background necessary for an awareness of why such standards exist and are enforced, and why artists have responded to official regulations of the art in particular ways.

## Historical Antecedents

The starting point for many surveys of Russian art is a discussion of the ambiguous relationship of Russian culture to that of Western Europe: the provincialism and isolation from new trends in European centers in the late nineteenth century and the self-conscious insistence on Russianness by many of the avant-garde artists of the early twentieth century. This historical separateness has certainly facilitated the suppression of modern art in the Soviet Union from the 1930s to the present.

Less attention has been given to the fact that the arts have been under state control in Russia from the mid-eighteenth century. The policy of control, whether in the form of benevolent patronage or repressive censorship, was firmly established in the nineteenth century. The few artists who sought to work outside the official academic system with its Civil Service ranks, perquisites, and censorship (such as the group of artists who left the Academy in 1863 and formed the *Peredvizhniki* or Wanderers' Association), had to contend with a multitude of official regulations and, if they were to survive, had to find a position for themselves with some relation to the academic system. The history of the various artistic movements and groupings around the turn of the twentieth century is one of briefly successful stands against authority, striking displays of independence, and in many instances eventual accommodation of some kind.

The politically convulsive period from 1905 to the mid-1920s provided the Russian avant-garde with opportunities for expression and development in many directions.[1] New cultural institutions formed under the provisional government and in the early years of the Soviet regime were composed of and directed chiefly by artists, writers, and other creatively active people—such as Grabar, Chagall, Kandinsky, Malevich, Tatlin, Gabo, and Lissitzky. There were state commissions for "revolutionary monuments" which allowed artists to experiment with new styles. However, some of the most interesting results of this surge of creative effort in the service of the Revolution have remained on paper—in sketches for projects that could not be realized under conditions of war-time austerity and insecurity and the subsequent totalitarian supremacy. Ironically, although the situations are quite different, the resourcefulness and dedication of many artists working under the severe material handicaps of the revolutionary and civil war years seems to have been prophetic of the spirit of artists facing the hardships and demands of the present decade.

After 1924 there were no significant exhibitions of avant-garde art in Russia and many of the major figures of the early modern movement had left the country. A crucial decree of 1932, "On the Restructuring of Literary and Artistic Organizations," established as the nation's sole legal artistic body the Union of Soviet Artists (ostensibly a democratic organization, but in fact an authoritarian one with more extensive powers than those of the prerevolutionary Academy). A decree of 1934 on the art of socialist realism (i.e., "the truthful depiction of reality in its revolutionary development") defined it as the only permissible form of artistic expression.

The brief encouragement of Khrushchev's "thaw" gave a chance for a number of artists including Neizvestny, Yankilevsky, Sooster, and a group from Bielutin's studio, to

exhibit together in two special rooms set aside for new art at the Manege Exhibition of 1962 (fig. 3). Khrushchev's emotional attack on this art made a brief sensation. [2] But within a remarkably short time a number of artists, including those represented in the general section of the exhibition, who also departed from the norms of socialist realism (Neizvestny, Weisberg, Birger, Sidur, and others) lost their posts or were forced into the position of artistic outlaws.

The relationships between totalitarian political systems and artists under such systems have been discussed in various contexts. [3] In the case of socialist realism, the imposition of a single, severely restricted mode of communication, suppressing all heretical voices, was both more inclusive and of longer duration than the comparable situation in Nazi Germany. The consequences—both for officially promoted art and for opposing tendencies—have, naturally, been more complex and far-reaching.

This book is concerned in part with the consequences of the policies which cut off Soviet art from the possibilities of a normal evolution. These include not only the obvious tension between the official and unofficial spheres of the Soviet art world but also an internal tension in much of the art itself: a tension between spiritual and material concerns, between satiric realism and transcendental nostalgia, and between poles even more difficult to pinpoint. Before discussing artistic aspects of the heritage of authoritarian control, we should review the present structure of the interlocking agencies of control.

**Organization of the Arts**

The primary directive laid down for the arts in 1932 is in essence still in effect. Art is directed to the task of educating the people in the spirit of Communism under the supervision of three co-acting organizations: The Ministry of Culture, The Academy of Arts of the USSR, and the Union of Artists of the USSR. All three have very broad powers and contain a number of departments which provide a basis for checks and balances within the system. The Ministry of Culture is the highest supervisory body: it controls the major art institutions and publishing houses; it sponsors international exhibitions and, through a special commission, it purchases works of art. It also has the authority to award special prizes and titles, such as "People's Artist of the USSR." The Academy of Arts of the USSR is the primary educational and research center in the country. Its branches (the Repin Institute in Leningrad and the Surikov Institute in Moscow) specialize in training artists and art historians, some of whom may be elected to membership and take part in the work of one of the Academy's decision-making councils. The Academy is the most prestigious art school in the country and it is the most conservative. Aside from obvious changes in overall goals, it remains basically a prerevolu- tionary institution in both its administration and its methods of teaching. But the benefits of study at the Academy, even for nonconformist artists, may outweigh the disadvantages. Therefore, the threat of expulsion for inappropriate behavior is one way of keeping students from seeking closer ties with the nonconformists.

The Union of Artists exerts direct control over the professional lives of artists. In an article on the "Mechanism of Control," Igor Golomstock breaks down the functions of the Union into four spheres—ideological, legal, economic, and artistic—by which it regulates the intentions or motives of artists, the means of practicing professionally, the possibilities of obtaining materials or selling work, and finally, the selection of works which can be shown to the public. [4]

About fifteen thousand artists are members of the Union, although this number includes craftsmen and designers as well as painters and sculptors. Those "art workers" who adhere at least to the letter if not to the spirit of Soviet socialist realism vastly outnumber the mere hundreds of artists who openly contest the aesthetic and philosophical authority of the Union. [5] The contrast is naturally intimidating, especially since the unofficial artists enjoy none of the considerable material advantages—studios, supplies, opportunity to exhibit periodically, and to sell their works, that Union members receive.

In the early sixties, some of these unofficial artists, in search of moral support and creative stimulus, began to interact and to form small groups such as Oskar Rabin's Liazanovo group and the Sretensky Boulevard group of Kabakov, Pivovarov, Yankilevsky, Shteinberg, and Bulatov. They have gradually attracted some friends and admirers, who, in the face of official neglect and outright hostility, have been of immense importance to them. [6] During the past three years, artists and concerned members of the public have been demanding a showing of unapproved art, though they do not expect a fair and unhampered showing. Their most dramatic move, which received international press coverage, was *The First Autumn Open-Air Exhibition,* held in the outskirts of Moscow on September 15, 1974. Although the proper steps were taken to obtain permission, the authorities immediately reacted as if to a provocation, and sent trucks and bulldozers to break up the exhibition. The leaders of the artists, some of whom were arrested, immediately protested against the illegal interference with their constitutional rights. As a result of this protest and widespread international criticism, the artists were permitted to hold a *Second Autumn Open-Air Exhibition* in Izmailovsky Park fourteen days later. This time, it proceeded in an orderly way, without police interference, and there was a noticeable *esprit de corps* among the eighty or so artists and the thousands of viewers. [7] Western journalists referred to it, rather inappropriately, as the "Soviet Woodstock;" Soviet artists, more realistically, congratulated themselves on "four hours of freedom." [8]

The long-range effects of these events cannot yet be predicted, but there may be some signs of change in the already ambivalent and tenuous relationship that exists between the art bureaucracy and the unofficial artists. Some official artists participated in unofficial exhibitions, thereby improving the chances for acceptability of these shows. Attempts were made to integrate some well-known unofficial artists into official organizations. In November, 1974, Rabin, Masterkova, and other unofficial artists were invited by the Moscow City Committee of the Union of Graphic Artists, to exhibit paintings, but, when they learned that they must first submit their works for approval they declined to participate. During the same period, other unofficial artists were subjected to continuing threats and attacks.

During the following two years, the government altered its policy toward unofficial art. In December, 1974, it permitted a four-day exhibition in Leningrad; in February, 1975, twenty unofficial Moscow artists mounted a six-day exhibition under the auspices of the Union of Graphic Artists while, at the same time a group of Leningrad artists was prevented from holding an exhibition and press conference in a private apartment. Some Moscow artists, recognizing a deliberate technique behind this arbitrary treatment, refused to participate in *The Union of Graphic Artists' Exhibition.*

Six small-scale exhibitions in private apartments took place simultaneously in the spring of 1975. A large exhibition

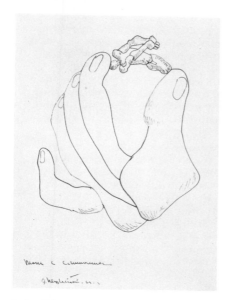

1. Ernst Neizvestny. Untitled, 1967
Ink drawing, 35 x 28 cm.

2. Ely Bielutin. *Two Figures,* 1967.
Monotype, 86.5 x 61 cm.

3. Sophie Schiller. *Gray Landscape* 1962.
Oil on canvas, 76 x 61 cm., shown at the Manege.

in Moscow (September 20-30) led to clashes between artists and authorities, and received a spate of adverse criticism. The official position on permissible art was communicated in an article in *Ogonek,* which disparaged abstraction and other modern trends as products of ideological sabotage from the West. [9] Evidently, the government permitted some nonconformist exhibitions in order to avoid an organized protest from the artists, but it did not relax its insistence on controlling not only artistic activities but also the style and content of art.

In the spring of 1976, the government made attempts to improve its control of the arts. In May, 1976, the exhibition *Seven Artists,* sponsored by the Moscow City Committee of the Union of Graphic Artists, was devoted to some of the more established unofficial artists. [10] Works by three of these artists—Otari Kandaurov, Vladimir Nemukhin, and Dmitry Plavinsky—were included in the officially sponsored exhibition at the Metropolitan Museum in New York in the spring of 1977. However, the works chosen are not considered by those familiar with the artists to represent their best work. There has been considerable debate as to whether this selection reflects the poor taste of the planners or is a device to deglamorize the avant-garde in the eyes of Western viewers.

In the early summer of 1976, the Moscow City Committee of the Union of Graphic Artists established a painting section and invited most of the unofficial artists to join. Presumably, this move would bring about the end of un-official art, since practically all artists would become "official." Despite this overture, Oskar Rabin and other leading unofficial artists feel that there has been no genuine change in government attitudes. Rather, the acceptance of nonconformist painters into the new section of the Union of Graphic Artists is viewed as an attempt to mislead world opinion, while in fact bringing the nonconformists under closer control. [11]

## Physical and Philosophical Characteristics

The preceding survey of the official organization of art in the Soviet Union, the conditions under which unofficial artists work, and the artists' recent, practical responses to the situation provide a background for examining more sub-jective questions. First, how have conditions affected the processes of creating art in the Soviet Union? Second, what special aesthetic characteristics in actual works of art can be traced to the situation within which they were conceived and executed?

Two general characteristics of unofficial art deserve particular attention. They arise out of conditions rather like those of nonestablishment art in the West. One notes a pervasive antimaterialist outlook and a tendency to execute works on a small scale and in series or sequences. The antimaterialism goes hand in hand with many artists' refusal to follow official Soviet regulations on art. Unable to receive government commissions or to sell their art openly, most unofficial artists must support themselves in other ways and devote their art to the satisfaction of their own creative ideals. Although they would like to have the value of their work recognized, they have no access to a proper market or to an objective critical evaluation.

Evgeny Mikhnov-Voitenko, an abstract painter, is illustrative of the artist far removed from the commercial world of art and creating primarily for his own satisfaction. He has painted over six thousand works, but has been willing to part with only a few. His crowded Leningrad apartment, which serves as his studio, is filled with folios and stacked with paintings. Similarly, Igor Tiulpanov, a Leningrad surrealist, works incessantly on his remarkably detailed, Van Eyck-like oils and his delicate and complex drawings, which suggest a world of a different order from that of his cramped apartment. He, too, parts unwillingly with any of the dozen major works he has created with such

painstaking care. In Moscow, the abstract painter Edward Shteinberg has followed his mystical artistic philosophy with single-minded concentration and has remained apart from the official art world. Although Vladimir Yankilevsky, Ilya Kabakov, and Viktor Pivovarov pursue careers as illustrators, their best creative efforts are expressed in work they do for themselves.

Igor Golomstock has pointed out [12] that the Soviet unofficial artists are barred from participation in the official mainstream of art, not because their work is politically tendentious (most of it is not), but because their main allegiance is not political (in the accepted Soviet sense) but artistic. They excluded themselves from official artistic life in order to preserve their private artistic worlds.

The sacrifices required by dedication to art rather than to the expected goals of socialist society have been serious enough to force artists to examine their motivations. Many have expressed their spiritual isolation and spiritual commitment in their works and in letters and published statements. For example, one of the best known of the abstract expressionists, Lydia Masterkova, who subsequently left the Soviet Union, described the nature of the artistic task as "to create, at the same time destroying." For Masterkova, the necessary conditions for creativity are lacking in Russia, conditions which permit the fusion of lofty inspiration and human sensibility. The sense of disjunction and isolation is exaggerated in Russia because "there is no feeling of the real world. There is only one's own world." [13]

Another, more tangible result of the restrictions on unofficial artists is the unimpressive size of most of their paintings. Large-sized canvas or paper is hard for non-Union artists to obtain, while other supplies may be prohibitively expensive for large works. Many unofficial artists lack separate studios and must work in crowded one- or two-room apartments, where there is never enough space to produce or store large-scale works. When available at all, studio space is likely to be small and unsuitable, located in a cellar or under the eaves at the top of an apartment building. Since the sale of paintings to the Ministry of Culture for museums or public buildings is closed to unofficial artists, they are only able to sell to private collectors. If Russian, the potential buyers live in apartments that are ill-suited for large works; if foreign, they must cope with shipping problems which limit the size of paintings they are able to acquire.

The small scale of most unofficial Soviet art has unquestionably been a handicap to its critical reception in the West. This is especially serious in the case of abstract expressionism in which size is part of the process and in pop art where size is a significant stylistic element, for example, in blown up comic strips or advertising. Even the visually powerful works of Masterkova, Rukhin, and Zilius are generally smaller than those of comparable American artists, and gain impact by being hung in pairs or groups. It is to be expected that the smaller works of Shteinberg and Boris Zhutovsky, for example, will have less impact on Western viewers than their larger works. Therefore, it is unfortunate that the few larger works of these artists may never be seen in the West.

Some Soviet artists have utilized this size limitation in inventive ways to create larger wholes from smaller parts. Artists in many countries are involved in serial art because of their interest in continuing forms beyond the "edge" or in repeating a theme. Soviet artists are working in a number of ways in interrelated series. Some, such as Mikhnov-Voitenko, work in diptychs and triptychs (fig. 4), an old tradition in Russian art.

Malle Leis, Yuri Dyshlenko, and Zhutovsky are among those involved in more extensive serial art. The serigraph series by Leis (fig. 53) usually involve changes in colors and color relationships, while the underlying designs remain unchanged. Dyshlenko's works often have such a continuing element. In his five-part series (fig. 50), a green band curves across the entire group, growing from a background shape to a matrix which seems to interact with other motifs that evolve, turn on imaginary axes, move forward or regress, in the successive pictures.

Zhutovsky also paints lengthy series of abstract works, often in the form of arrangements of closely matched pairs. The separate paintings may be only a foot wide and about three feet high, but a series of five pairs makes a work of impressive breadth. One of Zhutovsky's major works, painted in memory of his wife, consists of seven pairs of varying widths, each over six feet high. Properly hung, this combined work would stretch for more than twenty feet. Only a hint of this brooding and powerful work can be seen in the smaller, brighter examples available here in the West (fig. 66).

Some artists use series to develop ideas rather than to create large works from smaller ones. Each of the graphic works by the Estonian Leonhard Lapin can stand alone, but when shown together they reinforce one another and elaborate compositional or thematic concepts, as in his ten-part series *Woman Machine* (fig. 88). Zilius, originally from Lithuania, follows the Baltic tradition of working in series, both in his oils and in his large, dramatic graphics, which chronicle in semiabstract form the Soviet invasion of Lithuania in 1940 (fig. 37).

Yankilevsky, Kabakov, and Pivovarov, whose work is discussed in greater detail in Chapter Six have carried the concept of the series even further. They are primarily concerned with developing and expressing existential concepts. Yankilevsky has done several series on fertile traditional themes. In *Anatomy of the Senses* (figs. 130 and 131) and *City Masks* he seeks to lay bare the various layers of conventions, feelings, and definitions which have enmeshed human experience. Yankilevsky's sequences may be compared with works by Pierre Alechinsky (e.g., his *Imaginist Diary of 6-13 May, 1968*) and Adolph Gottlieb's pictographs of the 1940s. Like these artists, Yankilevsky uses representational signs in many ways: as ciphers, as formal figurations, and as narrative elements. The effect of the works depends on development of these signs in a series. Kabakov and Pivovarov, both of whom illustrate children's books for a living, produce deceptively ingenuous books for adults, creating what Kabakov himself calls a calm "dialogue" about the contradictions of life. [14]

The longest series of interrelated works executed in the Soviet Union is Neizvestny's sequence of multipart etchings, which were created at the rate of one a day over a period of a year in which the artist had been denied a studio. On an even more ambitious scale is Neivestny's plan for a monument entitled *Essence of Life* conceived in the Soviet Union several years ago. Intended to stand over four hundred feet high, its conceptual scale, embracing 2,000 years of civilization, is equally vast. Neizvestny is now at work on a series of plans, perspective drawings, and models. He is also executing successive small-scale sculptures of details which should ultimately be incorporated in full scale as part of the monument itself. While each of these smaller works can stand alone, together they represent the serial concept so characteristic of Soviet art, carried to its ultimate conclusion.

4. Evgeny Mikhnov-Voitenko. Untitled triptych, 1976. Gouache, 37 x 78 cm., overall, 37 x 24 cm. each.

Each of these artists has turned a material handicap into a basis for a distinctive mode of stylistic experimentation and expression. The importance of series and interrelated groups of works in the *oeuvres* of many unofficial artists forces us to change some habitual frames of reference in regard to this art. Despite some serious lacunae, it is now possible to look at these works, not as scattered artifacts, but as the products of particular stages of an artist's development and as parts of larger artistic ideas.

Many of the stylistic traits of contemporary Russian art may have originally derived from restrictions inherent in the Soviet cultural system; the development of these artistic means has, however, taken place above and beyond that system. It seems, indeed, that certain Soviet artists have coincidentally evolved modes of expression and communication parallel to those of contemporary conceptualist artists in the United States and Europe.

### Alienation and Its Modes of Expression

Alienation is not an inevitable consequence of the unofficial artists' enforced estrangement from the official Soviet art world. The question of how far artists can both be isolated from and yet retain a sense of identification with their society has troubled Soviet artists and will be taken up shortly. Here, however, the prevalence of styles and themes denoting rejection of contemporary Soviet norms and social expectations deserves comment.

Stylistically, alienation may take many forms. Falling somewhere between expressionism and abstract expressionism, Bielutin's aggressively emotional treatment of female nudes (fig. 49), which employ vividly contrasting colors and energetic, slashing brushstrokes, invites comparison with De Kooning's brutalized representation of women. According to his students, Bielutin's emphasis on rapid execution also serves as a kind of shock-treatment: to force artists out of conventional ways of visualizing and depicting figures. Hence, the style may be considered an outgrowth of a definite artistic aim. Other artists subject the human figure to the attack of paint in a way that sometimes seems to verge on the psychopathic, as in the portraits by Alferov and Anatoly Zverev (figs. 134 and 135). Vladimir Nemukhin, best known for his still-lifes, constructed of scattered and torn playing cards (fig. 56), has written that the act of distorting and pulling apart is connected with a subconscious protest against the static. As an artist, Nemukhin shares a common need with other artists to create dynamism and tension in an art that can respond to an inner protest and disquiet about life.[15]

Another effective means of denoting alienation from reality—depicting the actual invasion of human life by impersonal mechanisms—is illustrated by the highly-mechanical, mathematically precise, semiabstract prints of Leonhard Lapin, discussed in Chapter Three. It is significant that Lapin began working on purely abstract, geometrical lines; his unsettling erotic imagery is a later hybrid development (fig. 88). Lapin's series on man and violence, featuring automobile accidents and shootings, represent a horror of violence in the modern world and not just in Soviet society.

Petr Belenok's work represents a unique kind of semi-abstract art especially relevant to a discussion of alienation. Most of his work might be characterized as both abstract and surrealist. Small human figures are inserted into the midst of maelstroms of greyish tempera or black ink generated by the sweeping gestures of the brush (figs. 70 and 71). The emotional impact of these works depends equally on the sensation of abstract forces, and on the horrified recognition of human figures miniaturized by these forces.

Yankilevsky's awareness of the grotesque elements in contemporary life is expressed most effectively in a style which combines the directness of scatalogical graffiti with an intellectual objectivity perhaps akin to that of Paul Klee. The artist has stated that his satire is not solely concerned

with political abuses but rather seeks to expose the universal failings of the civilized human condition. His albums of *Mutants* and his series *Anatomy of the Senses* and *City Masks* give the impression of dissections of biological specimens in preparation for a scientific catalogue of the different varieties of supposed normality.

Thematically, the rejection of Soviet values may take the form of exotic or nostalgic subjects; religious themes or motifs from traditional religious art; or in another direction it may take the form of satirical or grotesquely realistic treatment of subjects from daily life.

Escapism, as such, is seldom a major motivation for unofficial Soviet artists. Indeed, it would be more accurate to say that official Soviet art is basically escapist, whereas artists who do not placidly follow the rules of socialist realism represent the reverse of escapism. Very often, however, subjects remote from everyday Soviet reality serve as necessary signposts for new directions.

Boris Sveshnikov, who studied art for two years before being sent to Vorkuta following the war, matured as an artist in the Stalinist concentration camps. Secretly drawing at night, he rendered familiar camp yards and corridors with delicate exactness, but he frequently injected unaccustomed viewpoints combining closed interiors with measureless exterior space. Some of his images come from Bosch and Brueghel, whose works seemed especially vivid to the exile in Siberia. Sveshnikov considered his *Prison Fantasies* to be "absolutely free art" because nobody but himself took any interest in it; it was completely private.[16] Fantasy seems to find especially fertile ground in such adverse conditions because it is largely independent of reality.

Valentina Kropivnitskaya's finely finished pencil drawings of peaceful landscapes peopled by quiet humanoid beings with rabbitlike, contemplative faces have an attractive sort of reversed exoticism. In such works as her *Russian Motif* (fig. 8), *Swamp,* and *Fairy Tale,* the viewer sees a distant Russian village as if through the eyes of a spiritually superior creature sensitive to the play of organic figurations, in harmony with nature, and happily removed from the sordid dissonances of everyday reality. Kropivnitskaya's adoption of nonhuman personae and her straightforward idealization and decorative style clearly distinguish her artistic intent from the self-conscious optimism of official artists.

Alexander Kharitonov's domain is also one of idealized nostalgia, but it is more complex than Kropivnitskaya's. His relatively small oils (fig. 51) are painted in a delicate pointillist manner which achieves a shimmering, mosaic effect. His drawings (fig. 82) are similarly composed of a web of tiny, separately curved strokes. His subjects are most frequently landscapes, featuring old Russian churches, medieval saints, crosses, and books, or, slightly less frequently, figures in empire costume distributed about the country estates typical of Pushkin's era. These visions of a spiritually remote era recall the highly refined retrospectivist and sometimes mystical works of Viktor Borisov-Musatov and other artists associated with the turn-of-the-century World of Art and Blue Rose groups.

A different variety of retrospectivism or nostalgia, in which religious symbols are employed to recall a vanished spiritual and social ethos characterizes Dmitry Plavinsky's major works (figs. 104 and 105). Plavinsky has written of his aim to express "what the object carries through time, that is, a certain degree of spirituality."[17] This statement echoes Malevich's comment on the persistence of the spiritual essence of certain art forms after the social structures that originally determined those forms have ceased to exist.[18] Malevich developed this notion in a series of practically

nonreferential drawings at the beginning of his suprematist period, whereas Plavinsky and other contemporary artists, in contrast, emphasize obviously referential forms (church cupolas, crosses, icons, Scythian, and Old Slavonic inscriptions). However, the later works share the transcendental quality which links them to Malevich's spiritual world. In other works, Plavinsky turns to motifs from nature or abandoned human artifacts (figs. 106 and 107) which suggest the wearing away of all particular forms by time.

Religious themes and motifs may signify concerns and loyalties foreign to the official atheism of the Soviet Union and as such they may signify an escape from constraints of the present and continuity with the past. (It might be noted that assertion of continuity and legitimacy has determined the style of much of revolutionary and present-day Soviet art—witness the omnipresent iconlike images of Lenin and other Soviet cultural heroes.) Religious symbols may be abstracted from their normal settings and used as artistic raw materials, but they do not entirely lose their traditional connotations. In the abstract works of Evgeny Rukhin, icons occasionally appear as textured elements of collages; they are of interest more for their association with the past than for their religious content. Icons of the Virgin of Tenderness type appear in many of Oskar Rabin's works, often juxtaposed with street signs and other details of the artist's surroundings in a neglected suburb of Moscow.

Usually such juxtapositions make the point that the contingencies of Soviet life come perilously close to destroying religion and art. For instance, in *Still Life with Fish and Pravda* (1968) a smoked fish is placed vertically against the spread of a torn and crumpled newspaper, on which one can read among the headlines: "Forward to the Dawn in the name of the Power of the People" and "Danger—Art," "Apathy Discredited," "Unbearable Loss," and a reference to Rabin's name next to a mocked-up section of abstract art photographs. A painting of 1964 sets the crucifixion of an armless Christ against a Russian urban skyline, and one of 1965 offers the laconic confrontation of a large road sign showing heavy trucks and the legend "Detour—2m" and the three cupolas of a village church. Related, but more programmatical, contrasts appear in Rabin's *Ferris Wheel, Evening* (fig. 112), a version of the medieval Wheel of Life theme, painted in memory of Rukhin, who died in 1976.

Both Sergei Esoyan and Yuri Zharkikh paint religious scenes in evocative expressionistic styles. The melancholy colors and the subtle textural quality of the paint in Esoyan's *Prodigal Son* (1975) and *Tower of Babel* (fig. 9) recall the early work of Rouault. The unusual medium developed by Zharkikh in 1971 allows a rich contrast of flat, slick, blistered and malleable impasto textures which, as in many of Plavinsky's paintings, contribute to an impression of age and organic growth and decay. One of Zharkikh's most impressive recent works combines a crucifixion with the mystical Tree of Life symbol of the continuing cycle of decay and regeneration. A multitude of disembodied heads (skulls or embryos) form a visceral mass about the blood-red foot of the cross, which spreads like tree roots or the legs of a striding, live man. Although very different in style, the metamorphosis of symbolic forms in this painting and the others done at about the same time suggests themes treated by Munch and Kokoshka.

A quite different, more philosophical, attitude toward religious symbols is contained in the 1974 manifesto of the "Petersburg Group" of artists led by Mikhail Shemyakin now a leader in the emigre art community in Paris. The statement begins with the axiom that "God is the basis of

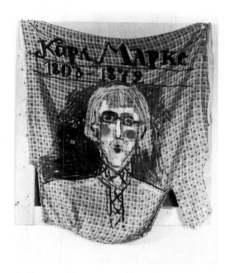

6. Vagritch Bakhchanyan. Untitled, 1969.
Mixed technique on paper, 35.5 x 44.5 cm.

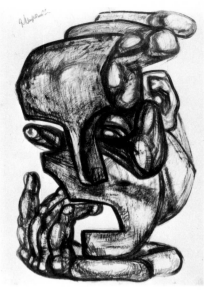

5. Komar and Melamid. *Young Marx,* 1976.
Oil on dishrag, 80 x 60 cm.

7. Ernst Neizvestny. Untitled, n.d.
Ink drawing, 91 x 62 cm.

Beauty'' and that ''Art means the path of Beauty leading to
God.'' It likens the icon to a natural flowering of religious
canon, and analyzes a range of universal symbols from those
of divine perfection to those of its antithesis, chaos. The
writers urge a return to a primordial artistic consciousness
based on an awareness of ''the religious sources of style''
and of the differentiation between styles which have evolved
according to religious principles. Some of this discussion is
reminiscent of Goethe's views on the nature of the Gothic
style as a unification of divine and natural laws. The text is
sprinkled with references to Goethe, the Renaissance,
Orphic mythology, Pythagoras, the Rosicrucians, Bosch and
the absurd, which seem appropriate to an aesthetic program
which the authors call ''Metaphysical Synthetism.'' [19] This
explication of the religious basis of art is quite far removed
from the contrast of orthodox religion with Soviet
materialism that relates specifically to Russia.

A special sensitivity to religious imagery as a means of
overcoming the restrictions of official cultural control is
shared by a number of Jewish artists in the Soviet Union,
some of whom have recently begun exhibiting as a group
both in Leningrad and, more recently, abroad. [20] Like other
unofficial groups, this one is based, not on similarity of styles
or even themes, but on a sense of shared concerns for
threatened values. The group members do not under-
estimate the dangers of identifying themselves as Jewish
artists: not only do they run the obvious risk of reprisals, but
they encounter the more subtle problems of distinguishing
between individual and national identity.

Those who identify themselves as Jewish tend to
emphasize ethnic subjects through colorful details of Jewish
life and to include Hebrew inscriptions in their paintings.
Some, however, concentrate on personal interpretations of
literary themes (not only from Russian and Jewish sources,
but often from Shakespeare, Cervantes, E.T.A. Hoffman,
and Poe—favorites of many young Russians). Still others,

such as Leonid Bolmat, Olga Schmuilovich, and the
sculptor, Yuri Kalendarev, do abstract work.

The work of Evgeny Abezgaus is chiefly concerned with
the life of the Jews in Russia (fig. 68). But the style of such
key works as *Adam Ate and Ate of the Fruit* recalls Russian
nineteenth-century *lubki* (popular hand-colored engravings).
Alek Rapoport works in a variety of media; some of his
works are not overtly Jewish. But his stylistically traditional
etching, *The Elder* (fig. 113) seems to express both the
antiquity of Jewish culture and also the sorrowful and
sensitive patience of the Jewish people. The lithographs of
the widely venerated Anatoly Kaplan (fig. 11), somewhat
reminiscent of those of Leonid Pasternak, have influenced
many Jewish artists of the younger generation. His themes
are from Jewish folklore and the life of the provincial *shtetl*.
Samuil Rubashkin, a cinema photographer and self-taught
painter who died in 1974, is still practically unknown, but a
large number of his works has recently been shown in
Leningrad and Moscow. The main subjects of Rubashkin's
''Jewish Cycles'' of 1973-74 are family events and traditional
Jewish ceremonies—a bar mitzva, a wedding, a family
Passover celebration (fig. 60), and a scene in a men's bath
(fig. 10). These, like many of his other works, are particularly
interesting for their primitive grid compositions, frontally
placed figures, and erratic perspective. Here, and in related
multifigured works, the pattern of small unmodeled figures
against a flat background seems to be as important as the
narrative situation.

There is no question that there are some Jewish artists in
the Soviet Union whose paintings deal with Jewish themes,
but the issues raised by the relationship of their religion to
their art are somewhat different from those raised in
connection with Jewish identity in the United States and
other Western countries. Indeed, the most telling
summation of the Soviet Jewish artists' situation, as artists
alienated in the way that all unofficial artists are, might be

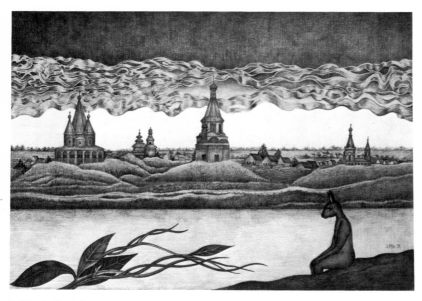

8. Valentina Kropivnitskaya. *Russian Motif,* 1976. Pencil drawing, 43 x 61.5 cm.

the words of Kafka quoted by Harold Rosenberg in an essay on the Jewish identity in a free society: "What have I in common with the Jews? I have hardly anything in common with myself."[21]

## Questions of Quality and Cultural Identity

The title of an article on Kabakov, Yankilevsky, Pivovarov, and their circle asserts that "Quality Is Its Own Reward."[22] The author, Robert Kaiser, points out that this group of Moscow artists exists for its members alone and shows little interest in the artistic mainstream in either the Soviet Union or the West. However, a question heard with increasing frequency by foreigners who visit Soviet artists is, "How would my work do in America?" Particularly those who do not have extensive contacts with Westerners and who see only occasional Western art publications are extremely sensitive to what they fear to be their weakness as provincials who lack a broad perspective by which to judge their own work.

Despite their enforced isolation from the Western world, unofficial Soviet artists are not content to have their art considered merely "of distinct historical and documentary importance as a reflection of Soviet counter-culture."[23] Nor, indeed, do many of them wish to change places with young European and American artists coping with the commercial art world. Nevertheless, there is a growing need among unapproved artists to expand their contacts and critical perspectives. *The First and Second Autumn Open-Air Exhibitions of 1974* and subsequent major showings, which allowed nonconformist artists to see their own work in relation to the aims and achievements of their peers, were a watershed for art within the Soviet Union. Recent exhibitions abroad in Paris, London, and other European centers are at least beginning to bring the Russians into a much broader frame of reference.

Much of the adverse criticism of Soviet unofficial art in both the Soviet and the Western press seems to rely on assumptions based on limited notions of unofficial art. Art is not necessarily interesting just because it is unacceptable to the authorities. Understandably, the "democratic" exhibitions organized by the unofficial artists have attracted some mediocre work which was immediately noted by the critics. This, however, is a condition of jury-free exhibitions everywhere and would automatically be taken into account in normal circumstances.

A routine accusation that the work of leading unofficial artists is "derivative" of American abstract expressionism, pop art, and other "outmoded tendencies" betrays an assumption that derivation is equivalent to plagiarism and is particularly reprehensible if the thing plagiarized is also disapproved.[24] Official Soviet attacks, sometimes anonymous, follow the line of letting the public feel superior to the artists in question by confirming that sensible people can see through the Western gimmicks that bedazzle the unapproved artists. Unfortunately, this notion has picked up so much momentum that non-Soviet critics have also been inclined to accept it too readily, and to neglect the differences between study and adaptation of other art and outright imitation.

Like art students in the West, Masterkova, Nemukhin, and other abstract artists studied Cézanne, Seurat, the cubists, and Malevich as well as the old masters, without at first feeling the need to work out their own positions with regard to older art. But as mature artists they recognized kindred ideas in the work of Western contemporaries and this undoubtedly helped them to define their own styles.[25] The influence of Rauschenberg and Johns, for instance, has been so pervasive and multifaceted in American art of the past decade that a number of young artists are clearly indebted to them. It is not surprising that Russians acknowledge the same debt.

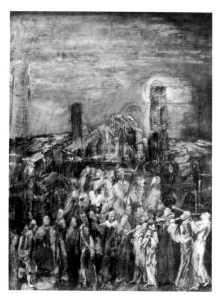

9. Sergei Esoyan. *Tower of Babel, 1965.*
*Oil on canvas, 74 x 68.5 cm.*

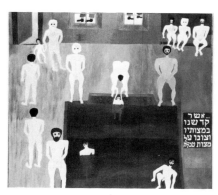

10. Samuil Rubashkin. *Bath,* 1974.
Oil on canvas, 75 x 80 cm.

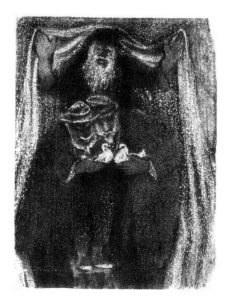

11. Anatoly Kaplan. *Matchmaker,* n.d.
Etching, 47.5 x 41 cm.

The issue is somewhat different for figurative artists, who tend to quote motifs from other art. A number of Leningrad surrealists continually testify to their admiration for Van Eyck, Bosch, Brueghel, and Callot, Italian trecento art, and Italian and Spanish mannerism. Tiulpanov's large oils, immensely impressive as monuments of Van Eyckian devotion to visual realism, are far more than derivations with the addition of some personal imagery. Tiulpanov has imbued himself with the respectful but not subservient attitude of the Northern Renaissance master toward the created world. But, as a modern artist, he has extended his domain beyond the concrete and toward the spiritual realm, not of fifteenth-century Christendom but of the twentieth-century Soviet Union. In *The Mystery* (fig. 63), according to his own explanation, he deals with the balance of good and evil in the real and the subconscious (spiritual) worlds. He uses not only traditional symbols and their interrelationships, but also subtle compositional adjustments that might have been suggested by careful study of Renaissance art. This certainly indicates a very active and individual application of his artistic sources to observations of the real world.

A major objection voiced by official spokesmen at a meeting with the artists who took part in the exhibition at the Gaz Palace of Culture in Leningrad in 1974 concerned the imitation of neoprimitivist styles of the early twentieth-century Russian avant-garde. This criticism had some justification. The primitivist works looked like raw imitation because they were not themselves the products of any coherent process of development. In the concluding chapter of this book, Igor Golomstock discusses the consequences of the disruption of the evolution of a Russian avant-garde and the unlikelihood of its being picked up afresh. Contemporary artists, while perhaps emotionally close to their Russian forerunners of the early twentieth century, are still separated from them artistically. Attempts

to revive any of the productive modes of avant-garde art are bound to be revivals rather than continuations of a tradition.

With perseverance, the isolation from a mature tradition may be turned to good account. Unaffiliated with any one artistic tradition, the Russian unofficial artists do not have to go through the process of casting off easy habits of perception and expression or convenient alliances. For the past two decades, the categorical division between socialist realism and unofficial art has been clear. Recent hints of some qualifications and shifts, primarily through gestures of tolerance from the authorities, probably meant to deflect and absorb some of the strength of the nonconformist movement, have not fully drawn the latter into the official sphere.

The wide diversity of styles discussed in this book and represented in the exhibition is obvious although, as the following chapters show, there are certain recognizable tendencies and groups. Increasing familiarity with unofficial Soviet art allows us to see that most of these trends have evolved over a respectable period of ten or even twenty years; it could not be said that they are merely responses to recent contacts with foreign art. Seeing foreign art (for instance at the important American graphics exhibition that toured the Soviet Union in 1963, which included works by Rauschenberg, Dine, Rosenquist, and others) gave some artists, such as Rukhin, needed confirmation of their own directions and also provided direct inspiration for specific new stylistic variations. But the crucial, immediate experience of new art was already conditioned to a great extent by the artists' own varied interests and previous preparation.

Although the present book and exhibition offer a far from complete survey of the works and concerns of unofficial artists of the Soviet Union, the selection does give an impression of the range and vitality of their work. It will disappoint those who seek an obvious "Russian aesthetic."

Not only are many of the artists not Russian but Estonian, Lithuanian, Ukranian or Jewish, but most of them resist any imposition of Russian national characteristics, which they identify with socialist realism. Chapter Seven points out the Party's equation of *narodnost* (national characteristics) with *partiinost* (party identification).

On the other hand, many of these works, particularly figurative ones, could at once be recognized as Russian if exhibited among works by Western artists. Some details that immediately strike a Western eye, such as Russian architectural forms and Cyrillic lettering, are not exotic from the artists' point of view. In contrast, non-Russian details, including Hebrew inscriptions and English words, have deliberate thematic significance (figs. 69 and 117). It should be noted that the frequent combination of letters, stenciled words, and entire verbal passages with visual images — a device now associated with pop art and conceptual art — has antecedents in icons and eighteenth- and nineteenth-century Russian popular images, in early twentieth-century avant-garde poetry and painting, and in Soviet propaganda art. Other examples of stylistic devices and images of mixed Russian and Western antecedents will be found in the essays which follow and in the works themselves. It would be difficult to unravel the strands of the different traditions that provided sources for this art, and to try to isolate them would be tantamount to accepting the official premise that there is one (approved) national art. Nevertheless, even with this caution, one hopes to find something distinctively a part of Russian or Soviet culture in this art — not to justify its existence but because this elusive quality may be in jeopardy.

Concern for the nonconformist artists remaining in Russia who are under increasing pressure in the Soviet Union should not make one overlook the fact that those who have emigrated are under pressures of another kind. Most obviously, art which seems interesting and topical merely because it has come from the Soviet Union attracts only a limited interest. Immigrant artists must establish themselves on a broader basis, as artists rather than emigres, and beyond this they must cope with conditions facing all unestablished artists in the United States and other Western countries.

Meanwhile these artists exist on the margins of two worlds, the art world and the network of Russian emigres. This marginal position undoubtedly affects their art, though specific results in the work of any individual artists cannot yet be identified. A marginal position is perhaps preferable to the personally threatening situation in which unapproved or dissident artists find themselves, but its equivocal and impermanent nature presents deeper problems. For people who have already sacrificed so much of their past, their cultural background, and their friendships on leaving the Soviet Union, the loss of these and other intangibles that were formerly necessary to their art can be psychologically devastating.

The focus of the media coverage on the artists' struggle for human rights in the Soviet Union has caused some observers to speculate that emigre artists, once removed from the immediate situation within the Soviet Union, will lose their *raison d'etre*. This notion follows from the mistaken idea that unofficial art is devoted entirely to exposing and protesting against reprehensible conditions in the Soviet Union. An even more pernicious misunderstanding is that their work is valueless outside the Soviet context. Artists can assert intellectual freedom without engaging in specifically political action, and they may do this best by continuing to work in their own way.

It would be a pity if the current of artistic integrity which has persisted in the harshest possible intellectual climate for so many years in the Soviet Union should become diluted and denatured when it encounters a more benign climate in the West.

The purpose of this book is to introduce a broad selection of Soviet art that falls outside the norms of socialist realism and to offer a preliminary basis for critical appreciation of it. The fairly extensive background material provided here has seemed necessary in order to compensate for the general lack of familiarity with this art and to challenge some misconceptions about it. The organizers of major exhibitions in Paris, Grenoble, London, and elsewhere have begun the work of bringing this body of art to the attention of the public. Igor Golomstock has addressed the problem of evaluating Soviet unofficial art, most specifically in an article in *Kontinent* (1976), in which he warns against a too inclusive identification of unofficial art with its particular, present-day situation in the Soviet Union and against adopting the notion of "dissidence" as an aesthetic concept. At the same time he rightly blames Western critics who ignore the Soviet context and insist on comparing isolated stylistic components (expressionism, surrealism, etc.) with the full ranges of these styles in Western art, and find the Soviet examples fragmentary and superficial by comparison. "To evaluate the artistic culture of one country according to the criteria of another, and to issue on this basis a copyright in originality to one of them is of little use to the historian."[26]

It is important at this stage to recognize the complex factors that contributed to the development of the various kinds of unofficial art in the Soviet Union. Bringing this art into the sphere of worldwide critical attention and evaluation may change some of our previous ideas about the complex processes involved in the development of Soviet unofficial art. Equally, we must be wary of hedging this art with too many preconceptions about the forms it might be expected to take as an unofficial body of art as such: it is unlikely that even one of the artists represented, let alone the entire group, will conform to any such preconceptions. Whatever their political principles are, these artists are not primarily motivated by political ideas. Their main concern is art, and their major task is to develop their individual visions and means of expression as fully as possible.

## Notes

[1] See John E. Bowlt, *Russian Art of the Avant-Garde: Theory and Criticism 1902-1934* (New York, 1976) for an historical survey, documentation, and comprehensive bibliography of this period.

[2] The Manege Exhibition is discussed in Paul Sjeklocha and Igor Mead, *Unofficial Art in the Soviet Union* (Berkeley and Los Angeles, 1967), pp. 85-102. See also R. Etiemble, "Pictures from an Exhibition," *Survey,* No. 48 (1963), pp. 5-18; John E. Bowlt, "Socialist Realism Then and Now," in *Russian Art 1875-1975: A Collection of Essays* (New York, 1976), pp. 177-78; John Berger, *Art in Revolution* (New York, 1969), pp. 81-86.

[3] Igor Golomshtok, "The Paradoxes of the Grenoble Exhibition on Unofficial Soviet Art," *Kontinent* 1974 (English version: Garden City, New York, 1976), p. 67 makes the point that the antifacist artists during the Third Reich often combined their work in art with political struggle whereas the first stages of Soviet unofficial art belonged to a very different struggle: he develops this idea in Chapter Seven of the present book. Cf. also I. Golomstock, "The Language of Art under Totalitarianism," *Kontinent,* No. 7 (1976). Harold Rosenberg, "The Academy in Totalitaria" (1963), published in *Discovering the Present* (Chicago, 1973), pp. 93-99 makes general

analogies between academicism and totalitarianism in Nazi Germany and Stalinist Russia.

[4] Igor Golomshtock, "Unofficial Art in the USSR: The Mechanism of Control," *Studio International,* vol. 184 (October, 1974), p. 40. See Elena Kornetchuk, "The Politics of Soviet Art," *Bulletin of Atomic Sciences* (in preparation), for detailed discussion of these agencies.

[5] The number of unofficial artists is unknown but is in the hundreds rather than the thousands. Besides these there are groups of artists outside the Union membership, the so-called nonprofessional artists, the national and amateur artists of various republics, and artists who work for theaters and publishing houses. In general, they do not protest against socialist realism, but they do have more leeway for experiment than do the Union members.

[6] See Chapters Two and Seven of the present book. For personal notes on the importance of public support, cf. Alexander Glezer, "The Struggle to Exhibit," in Golomshtok and Glezer, *Unofficial Art from the Soviet Union,* pp. 107 - 20, and an interview with Alexander Kalugin, *Ibid.,* pp. 121-22.

[7] Alexander Glezer, "The Struggle to Exhibit," *Ibid.,* pp. 112-16, gives a vivid account of the two Open-Air Exhibitions. See also Aleksandr Glezer, compiler, *Iskusstvo pod buldozerom* (London, 1975).

[8] Robert Toth, *Los Angeles Times,* (September 30, 1974). Oskar Rabin, one of the organizers, called the *Second Open-Air Exhibition* the freest that had ever been held in the Soviet Union.

[9] D. Nalbandyan, "False Values of Abstractionism," *Ogonek,* No. 32 (August, 1975), p. 20—accused the unofficial artists, which he lumped together as abstractionists of showing "a snobbish indifference to the labors and struggles of the people" and a pretentious imitation of outmoded Western styles which they did not understand in any case.

[10] The artists were Viacheslav Kalinin, Otari Kandaurov, Alexander Kharitonov, Dmitry Krasnopevtsev, Vladimir Nemukhin, Dmitry Plavinsky and Nikolai Vechtomov. The exhibition ran from May 11 to May 18. A comparable exhibition was held by the Moscow Union of Artists in August, 1976. In Leningrad, a group of abstract artists—Borisov, Vasiliev, Dyshlenko, Ross, Mikhnov-Voitenko, and Putilin—held an officially approved exhibition, *Painting, Graphics, Object,* November 10 - December 3, 1976.

[11] Cf. Glezer, "The Struggle to Exhibit," p. 119.

[12] Golomstock, "Paradoxes of the Grenoble Exhibition," *Kontinent,* p. 71.

[13] Masterkova, letter of 1969, published in Golomshtok and Glezer, *Unofficial Art from the Soviet Union,* pp. 150-52.

[14] Statements by Yankilevsky and Kabakov, *Ibid.,* pp. 147, 161-63.

[15] Nemukhin, statement, *Ibid.,* p. 153.

[16] Sveshnikov, statement, *Ibid.,* p. 93.

[17] *Ibid.,* p. 97.

[18] Malevich formulated this idea in *The Non-Objective World,* and returned to it in a negative way in "The Question of Imitative Art," in Troels Andersen, ed., *Malevich: Essays on Art,* 2 vols., I (Copenhagen, 1968), p. 170.

[19] Mikhail Shemyakin and Vladimir Ivanov, "Metaphysical Synthetism" (1974), in Golomshtok and Glezer, *Unofficial Art from the Soviet Union,* pp. 155-57.

[20] See the catalogue of photographs taken from the exhibition in Abezgaus' apartment, November, 1975: *Twelve from the Soviet Underground,* (Berkeley, California: Judah L. Magnes Museum, 1976).

[21] Harold Rosenberg, "Jewish Identity in a Free Society," *Commentary,* (1950), reprinted in *Discovering the Present* (Chicago and London, 1973), p. 223.

[22] Robert Kaiser, "Where Quality Is Its Own Reward," *Washington Post,* December 22, 1974.

[23] John E. Bowlt in *Art News,* July - August, 1977, p. 107.

[24] D. Nalbandyan, "False Values of Abstractionism," *Ogonek,* No. 32 (August, 1975).

[25] Cf. statements by Masterkova and Nemukhin in Golomshtok and Glezer, *Unofficial Art from the Soviet Union,* p. 152.

[26] Golomshtok, "Paradoxes of the Grenoble Exhibition," *Kontinent,* p. 65.

# 1 Moscow: The Contemporary Art Scene

John E. Bowlt

For the western historian to attempt to evaluate modern Soviet art, whether "official" or "unofficial," is a hazardous venture especially if he lacks an adequate knowledge of the political structure of the Soviet Union and of the brief but dynamic developments in Russian art of the nineteenth and twentieth centuries. It is, perhaps, a neglect of the foremost traditions of nineteenth-century Russian art that has caused the modernist movement, particularly its contribution to the notion of abstraction, to assume such extraordinary stature in the eyes of Western observers. The importance of the Russian avant-garde in twentieth-century art as a whole must not be underestimated. But the strength of the Russian avant-garde lay not only in its nonfigurative creativity but in its figurative or "relevant" output—the cubo-futurist and aerial suprematist phases of Malevich, the functional designs of Popova and Tatlin, the propagandistic photographs of Rodchenko, even the spiritual landscapes of Kandinsky.

The presence of a figurative tradition, which was comprehensible to the masses as well as the intelligentsia, provided socialist realism with a strong popular base. The same figurative, concrete element also applies to the work of the artists who oppose socialist realism. The importance of the world of objects and the force of narrative to the unofficial artists was underlined by Oskar Rabin when he asserted that "it is my nature, evidently, to express myself by means of objects. This, I feel, is my strongest aspect."[1] Bearing this statement in mind, one may ask whether modern Soviet art, unofficial or official, has in any way altered the fundamental, realist aesthetic of Russian culture.

## Socialist Realism or Surrealism?

The many ideological proclamations on art advanced by Bukharin, Gorky, Zhdanov, and others at the First Congress of Soviet Writers in 1934, the forum at which socialist realism was defined as the only viable credo for writers, artists, and musicians are still in effect today. The meaning and phraseology of dicta such as "reality in its revolutionary development," "truth and historical concreteness . . . combined with the task of ideological transformation and education of the working people in the spirit of Socialism,"[2] have changed little during the past forty years. But the fact that these principles still enjoy mass popularity might indicate that they are not, perhaps, alien to the nation's cultural consciousness. Socialist realism entailed the imposition of a socio-political ideal on the depiction of concrete reality. It was, in other words, a combination of the unreal and the real. As Zhdanov urged in one of his speeches: "Romanticism cannot be alien to our literature . . . but it must be a romanticism of a new kind, a revolutionary romanticism . . . revolutionary romanticism must enter literary creativity as an integral part."[3] The resultant tension between idea and image allowed the more whimsical artist a degree of elasticity: the abundant harvests bathed in sunshine, the smiling faces of shipyard workers, the ardent scholar at his desk, Stalin clothed in the white rainments of Christ—such paint-

ings were essentially romantic and remote from Soviet reality.

In view of this tradition, it is understandable that the most widespread, but, unfortunately, not the finest, art trends supported by the Moscow unofficial artists are variants of surrealism and expressionism rather than abstraction. The "unreality" of reality also seems to attract the younger generation of official artists, so that the dominant mood at such major exhibitions as The USSR Is Our Motherland (Moscow, 1973) is contemplative, lyrical, and romantic.

The first dissident artists of the 1950s, such as Alexander Arefiev in Leningrad, also rejected the grandiose ideals of socialist realism—its illusions of solidarity, rhythm, optimism, and conviction. But they did so by resorting not to the effete sentimentality displayed by many contemporary official artists (see, for example, Igor Obrosov's touching Little Girl with Swallows)[4] but to the shocking exposure of everyday Soviet life (fig. 12). These were the "barracks' artists,"[5] who drew and painted the slums and factories of Moscow and Leningrad, the market-places, the alcoholics, and the streetwalkers. They were, in fact, the predecessors of Oskar Rabin.

## Consolidation of Forces

Unofficial art in its present sense began after the death of Stalin. The "thaw" in literature following Khrushchev's denunciation speech of 1956 encouraged parallel developments in art. Just as poets began to hold public readings, so artists, who formerly showed their "religious," "pornographic," or "anti-Soviet" works only to trusted friends, began to hold viewings in their own apartments and in workers' and students' clubs in Moscow. In the early sixties, the frequency of such exhibitions increased. Ely Bielutin played an important role as both an artist and as a teacher who gathered a strong following of abstract expressionist painters (figs. 2, 3, 49, and 73). Bielutin's studio held an exhibition in 1962, which raised hopes for some degree of official recognition. The invitation to Bielutin, Neizvestny, and others to participate in the official exhibition Thirty Years of Moscow Art seemed to be a realization of these hopes.

Paradoxically, open conflict between the "official" and the "unofficial" artists of Moscow—between those who supported the conventional interpretation of socialist realism and those who did not—took place in December, 1962 at this now famous exhibition. One significant aspect of the Manege affair was that the experiments in figurative art presented by Ernst Neizvestny (and by the older generation, some of them long deceased, such as Alexander Drevin, Robert Falk, Andrei Goncharov, and David Shterenberg) enraged Krushchev as much as, if not more than, the non-figurative pieces contributed by Ely Bielutin and his abstract expressionist group. It has been suggested[6] that Vladimir Serov, then president of the Academy of Fine Arts, was responsible for the inclusion of deviationists in the exhibition, since he knew full well that Khrushchev would respond with

the exclamation: "We are going to maintain a strict policy of art . . . . Gentlemen, we are declaring war on you!"[7] This statement, incidentally, was a clear echo of Hitler's declaration made in 1937 on the eve of the *Entartete Kunst* exhibition: "From now on we are going to wage a relentless cleaning-up campaign against the last subversive elements in our culture."[8] On many occasions Serov also expressed his antipathy to the works of the "troubadours of formalist searches"[9] and upheld what he considered to be the fundamental tenets of socialist realism until his death in 1969. It was during the early 1960s, in fact, during Serov's hegemony, that the division between official and unofficial factions within Soviet art was recognized as a serious and corrosive process, prompting Khrushchev to emphasize that the "strength of Soviet literature and art—the method of Socialist Realism—is in the truthful depiction of the chief and decisive elements in reality."[10]

The Moscow underground movement of the 1950s and 1960s flourished both as a protest mechanism and as an aesthetic experiment, thereby forming an organic link with the delicate and clandestine avant-garde of the Stalin era: the drip canvases of Rodchenko and the fantasies of Alexander Tyshler. Just as public poetry readings were held, so private art exhibitions were organized, both bypassing the censor; just as manuscripts began to circulate with astonishing rapidity, so a new network of private collectors began to acquire the old and the new Russian avant-gardes; just as Yevtushenko became the hero of the new Soviet writers, so Ernst Neizvestny became the accepted leader of the new generation of artists. Despite his recantation in *Pravda* in March, 1963,[11] Neizvestny went on to become the subject of international discussion, of publication, and of the attention of august institutions such as the Museum of Modern Art in New York. Like Yevtushenko and Voznesensky, Neizvestny, now living in emigration in New York and Zurich, is remembered for past glories, while his work, more original and gripping than Yevtushenko's, has lost some of its former vigor and purpose. Of course, Yevtushenko and Neizvestny were symbolic figures whose gestures gave direction and encouragement to a new wave of writers, artists, and artistic events in Moscow.

Other Moscow artists appeared in the wake of Neizvestny, such as Dmitry Krasnopevtsev, Dmitry Plavinsky, and Anatoly Zverev, each attracting his own Soviet and Western clienteles. Important exhibitions such as the Robert Falk retrospective in 1966, the Rodchenko in 1968, and the Tatlin in 1977, opened in Moscow; private collections continued to grow and even to go on tour. Above all, society and its tastes were changing: all these conditions threatened the edifice of socialist realism and prompted the establishment of an aesthetic substitute.

In the mid-1960s it seemed that such a substitute existed, in the unofficial movement, and that this new school of artists was on the threshold of unprecedented discoveries. Now, a decade later, we can look back with a more measured eye and determine more clearly the successes and failures of that nascent avant-garde and the developments that have ensued. This act has been facilitated by the several recent "official unofficial" exhibitions in Moscow—*The First Autumn Open-Air Exhibition* on September 15, 1974 (the "bulldozer affair"); *The Second Autumn Open-Air Exhibition* on September 29, 1974; *The Exhibition of Economic Achievements* at the Bee-Keeping Pavilion in 1975; *Seven Artists* organized by the City Committee of Graphic Artists and *The Experimental Exhibition* at the Artists' Union in 1976; and the exhibition organized by the City Committee earlier this year. This cycle of exhibitions

has, as it were, stratified and delineated the various directions within contemporary Moscow art. At this point, the terms "unofficial" and "official" cease to have distinct meaning since many of the contributions have been bland and innocuous and, in any case, members of the Union of Artists of the USSR have been well represented both at these and other unconventional exhibitions.

**The Medium Is Not the Message**

In one of Oskar Rabin's paintings, *Still Life with Fish* and *Pravda* (1968), a headline from *Pravda* reads: "Careful, Art."[12] However ironic Rabin's gesture, this caveat summarizes an important and typical attitude to art in the Soviet Union. Whether "official" or "unofficial," art, for the Russian, is an instrument of conversion and transformation. In the Western world art is no longer imbued with this magic power. This essential difference in attitude to art makes Soviet culture as a whole difficult to understand and appreciate in the West.

Much journalese has been devoted to the topic of Soviet unofficial art, especially that of Moscow, but, in most cases, its unofficial aspect has received more attention than the artistic aspect. The connotations of unofficial art evoke a political idea that can be manipulated and exaggerated by the press. A second and unfortunate reason for this current political interpretation is that unofficial art in the Soviet Union has produced little of permanent aesthetic worth (judged from a Western viewpoint). Despite gross generalizations concerning the sympathy with which the exhibitions *La peinture russe contemporaine* (Palais des Congrès, Paris, 1976) and *Unofficial Art from the Soviet Union* (Institute of Contemporary Arts, London, 1977) were greeted, the artistic significance of these events was questionable. As Caroline Tisdall wrote in her review of the London show: "Without all the fuss and outraged howls of indignation that the West habitually hurls against the East, it would certainly not, as art, be the subject of such heated debate and extensive media coverage."[13] Of course, it is dangerous and presumptuous for a critic to attempt to divorce "ethics" from "aesthetics" and "unofficial" from "art," but, ultimately, this has to be done. Matters are complicated by the fact that what was regarded as "unethical" a few years ago is now acceptable: members of the Union of Artists of the USSR contributed to the above exhibitions and to others organized at home; unofficial artists contributed to the recent exhibition of *Russian and Soviet Painting* at the Metropolitan Museum of Art, New York and the M.H. de Young Memorial Museum, San Francisco.

The contemporary art scene in the Soviet Union is an eccentric one because, with some major exceptions, the important achievements in art are being made not in the ostensible centers of cultural life, Moscow and Leningrad, but, rather, in the provinces, especially in the Baltic states, and, of course, beyond the frontiers of the Soviet Union. Indeed, a number of the pioneers of Soviet unofficial art— Mikhail Shemyakin, Henry Elinson, Lydia Masterkova, Lev Nusberg, Vasily Sitnikov, Ernst Niezvestny—now live outside the Soviet Union. They live no longer in martyrdom but in a sybaritic society that tends to regard artistic creation as a form of recreation. They find it hard to stimulate general interest in the urgent political tasks of Soviet art, the more so since the art in question belongs to a specific political structure. Ironically, it may be that the lyrical kitsch of official Soviet art, like plastic gnomes in the suburban garden, is more appealing than most unofficial art to western taste. Official Soviet art is becoming increasingly sentimental,

13. Lev Nusberg, *Construction II*. 1963, 58.5 x 81.5 cm.

12. Aleksandr Arefiev. *Poet Inspired by the Muse, 1956.*
1956. Watercolor, 31 x 26.5 cm.

14. Viacheslav Koleichuk. *Butterfly,* 1974 Plexiglass.

anonymous, and apolitical. But, as a matter of fact, this department store style is also becoming evident among the unofficial artists, especially those in Moscow: there is, essentially, no difference in mood or purpose between Andrei Mylinkov's *Morning* (1973, a nude asleep in a pristine landscape, shown at many official exhibitions) and Leonid Purygin's *My Home* (1975, shown at *The Experimental Exhibition* last year), or between Igor Ershov's fairy-tale illustrations and Valentina Kropivnitskaya's fantastic animals.

Unofficial Moscow art shares, in many instances, the predicament of socialist realism of the 1930s to 50s; that is, it tends to rely on a particular, temporal set of conditions that comparatively few people can recognize and value. Boris Sveshnikov, for example, one of the most sincere and most moving painters of the Moscow group, painted a picture entitled *The Coffin Maker's Workshop.* The image of the emaciated, frozen man on the edge of a coffin is a terrifying one, but it is difficult to appreciate in full unless one is familiar with the funeral conventions of the Soviet prison camp: that since the ground of the Siberian prison camp is too frozen to bury the dead in winter, the bodies and their coffins must wait for the spring. Similarly, one has to have experienced the Moscow communal apartment in order to understand the *taedium vitae* expressed in Oskar Rabin's paintings. Ignorance of this subtext renders the full meaning of unofficial art inaccessible to the Western viewer.

This state of affairs applies especially to the satirical work of the Moscow artists Ilya Kabakov, Lev Kropivnitsky, and Vitaly Komar and Alexander Melamid (although the latest Komar/Melamid exhibition at the Ronald Feldman Gallery in New York earlier this year demonstrated their new trend towards an "international" parody relevant both to Brezhnev's Russia and to Carter's America). To a consciousness familiar with the "objectness" of the Soviet state, with its emphasis on titles, documentation, and mechanical explanation, Kabakov's artful labeling of a teapot as a teapot (1975) or

sky as sky (1971) is an amusing and incisive comment. In their inviolable and frightening logic, these pictures remind us of Vsevolod Nekrasov's poetry:

Freedom is
Freedom is
Freedom is
Freedom is freedom. [14]

The repetition, not the clarification, of an assumed truth is the device whereby most political regimes survive. Poetic confrontation with this positivist reality of "absolute truths," with this exclusive world of appearances, accounts, in turn, for the frustration and deep despair evident in the contemporary expressionist school of Moscow—represented by Anatoly Brusilovsky, Viacheslav Kalinin, Alexander Makhov, and Boris Sveshnikov, and also, until their emigration, by Vladimir Galatsky, Vladimir Rykhlin, and Alexandr Zlotnik. The crippled forms in works such as Kalinin's *Self-Portrait* (1974) and Rykhlin's *Russian Market Scene* (ca. 1970) reflect not only the banality of "barracks" Moscow [15] but also the artist's response to a crazy world that can deform facts and figures out of all recognition. The resultant mood of depression and claustrophobic horror prompts such artists to cultivate themes of putrescence, decomposition, and death. The theme of necrophilia is a traditional one in Russian art, particularly among the realists and the symbolists, but the pessimism and morbidity conveyed by the Moscow expressionists are unprecedented. It is tempting to compare their work with the First World War etchings of Otto Dix and the early, expressionist work of Yuri Pimenov and Tyshler, all of whom were living in a time of fundamental dislocation and disruption of all moral and social norms.

**Imitation and Inspiration**

A criticism which is often leveled at the unofficial Moscow artists concerns plagiarism and imitation both of modern Western art and of the earlier Russian avant-garde. To some

15. Viacheslav Koleichuk. *Net Composition,* at the Soviet Pavilion, Expo '75, Okinawa, Japan. 1975.

extent such an allegation is justified, and one can scarcely agree with Alexander Glezer when he writes that "all this [art] has been born in no way under the influence of ideas coming from Europe and America. It has been born on Russian soil." [16] There were clear examples of stylistic and thematic derivation at the recent official, unofficial exhibitions, such as *The Experimental Exhibition* at the Artists' Union last year: Sergei Volokhov's *Rape of Europe* (1975) was a direct copy of Magritte's *Rape*; Nikolai Punin's *Frisby* (1975) repeated the photorealism of Richard Estes and David Parrish. But perhaps this practice of reproducing images and methods of other schools is not so pernicious as it might appear. As Alexander Shevchenko, a member of the old avant-garde, wrote in 1913: "Painting is a visual art and, as such, can choose its object of imitation freely, i.e. nature or another work already in existence. One should not be afraid of copying other people's pictures . . . in two works of art that resemble each other in subject, there will be a different kind of painting, different texture, and different structure." [17]

We should not forget that for over thirty years, the Soviet Union did not import, exhibit, or publicize contemporary Western, experimental art with the result that her museums lack essential examples of work by Dali, Magritte, Mondrian, Pollock, and others. Now, in 1977, times have changed somewhat, and no Soviet critic would repeat such absurd statements of the 1930s as "Cézanne is to be condemned. Matisse does not know how to draw. Picasso is putrid." [18] Even so, while cubism can be "forgiven," nonobjectivity and surrealism cannot—as lead articles in Moscow art journals still emphasize: "At an exhibition of the avant-gardists I saw one extremely cynical exhibit: one canvas was hanging . . . with a huge nail stuck through it; a second canvas was completely turned round to the wall with its stretcher towards the viewer—and also had a nail through it. This demonstrated a complete denial of art . . . . A mother and her son, a soldier giving his life for his country and many other things could have been depicted on this canvas." [19]

Only during the thaw, did young Soviet artists begin the laborious task of condensing and assimilating thirty years of international artistic development. This condition explains, in part, the rashness and repetitiveness in much of unofficial art. That is why imitation and derivation play such a decisive role in the present state of the Soviet avant-garde. In turn, this laboratory phase provides good reason for expecting an intense period of discovery and innovation, unless—as may happen—emigration, fragmentation, and transference of loyalties render this subsequent evolution impossible.

### Universality

Within the intricate mosaic of Moscow's unofficial (and official) trends, there are certain artists whose work does seem to contain an enduring aesthetic value, to avoid specific political and social subjects, and to enjoy, therefore, a more universal appreciation. Among these artists are Vladimir Nemukhin and Oleg Tselkov, both of whom, paradoxically, are members of the Artists' Union, and both of whom find a common source of inspiration in the ideas of Malevich. As Tselkov wrote recently: "One has the feeling that it is as if he [Malevich] subsumes all his emotions into an apparently very simple formula. Without losing or rejecting anything, he manages, figuratively speaking, to express the most profound emotional idea in a couple of words. Malevich taught me simplicity." [20] Moreover, just as Malevich imbued much of his suprematist work with a cosmological or spiritual content, so both Tselkov and Nemukhin believe that "pure abstraction simply does not exist. What is it? Nothing? No. It is the artist's world and hence no more an abstraction." [21]

Tselkov and Nemukhin develop this assumption in opposite ways: Tselkov adds a philosophical dimension to his painting; Nemukhin relies on the veiled image—the torn

23

16. Francisco Infante. *Thorny Flower*, 1968. Mechanical kinetic structure.

17. Francisco Infante. *Crystal*, 1972. Fragment of a kinetic work at the VDNKh exhibition.

playing card, half a face—to express a very personal refraction of the world, and, despite his particular interest in the formal elements of painting, the objects still serve a vital, extrinsic purpose. Tselkov creates meaning through a "universal" image (fig. 123), emphasizing the religious function of art. On this level, Tselkov maintains a traditional attitude of the Russian artist, one that has been voiced again and again in modern times—from Kandinsky ("true art never fails to act upon the soul")[22] to Vasily Chekrygin ("the eternal order . . . illumines the religious essence of the true artist").[22]

Tselkov's art and theory bring to mind the work of Pavel Filonov, an artist who was also concerned with the universality of his artistic depiction. It is instructive to compare Tselkov's rendition of the "social model of the whole of mankind[24] with Filonov's principle that "activates all the predicates of the object and of its orbit: its own reality, its own emanations, interfusions, geneses, processes in color and form—in short, life as a whole."[25] Filonov is especially relevant here since, in any examination of the Moscow unofficial artists, the Russian expressionist "movement" should be remembered. Plavinsky, O. Rabin, Yankilevsky, and Zverev do, in many ways, carry on the "alternative tradition" of Russian art—that tradition which connects Mikhail Vrubel, Filonov, Kandinsky, Vasily Masiutin, Viktor Zamirailo, and Chekrygin but which bypasses the suprematists and the constructivists. Moreover, just as a dual vision (Filonov/Tatlin, Kandinsky/Popova) was the prerogative of the old avant-garde, so the new Moscow school offers the same alternatives of divination and calculation.

## Kineticism

The search for a more constructive, more calculated art form, for what has been called "artistic technology," is much indebted to Lev Nusberg, a self-taught artist who,

during the late 1950s rapidly assimilated the methods of Kandinsky, Malevich, and Miro, finally arriving at kineticism in 1961. Together with Galina Bitt, Francisco Infante, and others, Nusberg established the *Dvizhenie* (Movement) group in 1962 in Moscow, and the following year some of their constructions were displayed at the Moscow House of Art Workers under the title *Exhibition of Ornamentalists*—a description that linked the group automatically with the decorative arts and hence circumvented the demand for overt political content.

*Dvizhenie* showed kinetic constructions at various institutions in Moscow and Leningrad; associates of the group took part in conferences devoted to themes such as *Light and Music* (Kazan, 1969) and designed the layout for several scientific and cultural exhibitions such as *Fifty Years of the Soviet Circus* (Moscow, 1969). In 1965 *Dvizhenie* issued a program entitled "What Is Kineticism?" which presented the principal tenets of Nusberg and his colleagues (at that time): "We demand the utilization of all potentials and all media, all technological and aesthetic, physical and chemical phenomena, all forms of art, all processes and forms of perception as well as the interrelationship of physical reactions and the action of various human mental impressions as a means of artistic expression."[26]

Because of personal and ideological frictions, the collective changed continually, although Nusberg (fig. 13) remained the leader of *Dvizhenie* until his emigration in 1976. The political stance of the collective and of the kineticists presently working outside its confines such as Viacheslav Koleichuck (figs. 14 and 15) and Infante (figs. 16 and 17), is an ambiguous one. On the one hand, their work is appreciated by such governmental organs as the Ministry of Building and the Ministry of Radiotechnological Industry; yet on the other, it is discounted by the Ministry of Culture and the Union of Artists of the USSR. Thanks to this peculiar divergence of views, the kineticists were allowed to formulate

various exhibitions and even to contribute to the Leningrad decorations in honor of the fiftieth anniversary of October, but Nusberg was refused membership in the Union of Artists. Similarly, Infante and his colleagues, now forming a new group called ARGO (*Avtorskaya Rabochaya Gruppa*) created an "artificial kinetic environment with the active use of chromomusic, plastic organization of space, and various forms of movement"[27] for the international chemistry exhibition in Moscow in 1970, yet Infante has never had a public one-man show. Perhaps the saddest consequence of this twilight existence is that beyond official commissions, materials are very hard to procure, so that many projects remain at the preparatory stage. Among many such embryonic schemes were Nusberg's designs for a total pleasure garden environment and for a pioneer camp center (partly implemented at a Black Sea resort in 1968).

Francisco Infante, indebted to Nusberg's initial kinetic ideas, but now following a different path, is one of Moscow's most gifted artists and constructors. Convinced of man's ultimate inhabitation of the cosmos, Infante has designed a series of forms that, while floating and revolving, would create artificial environments in space or would operate simply as abstract constructions — in which color, sound and light would play roles as important as the structural axes themselves. Infante describes his new conception in the following way: "Our age is remarkable for a new quality — it has begun to create systems and models which, *in their effect,* can reproduce processes and phenomena analogous to natural ones. This is no longer the reflection of nature, but the creation of artificial systems, 'living' according to the laws of nature and developing by analogy with nature . . . ."[28]

It is precisely in the work of Infante and ARGO and, until last year, of Nusberg and *Dvizhenie* that we can perceive the support and evolution of the great Russian constructivist traditions of the 1920s, especially as they related to the whole notion of architecture and environmental design. This audacious and innovative approach to *three-dimensional* reality, together with a full acceptance of technological advance, links the Moscow kineticists to pioneers such as Naum Gabo, El Lissitzky, Rodchenko, and Tatlin (however different their respective aesthetic systems). Of course, the kineticists are interested in a mobile art form, something investigated only partially by the old avant-garde, although Gabo certainly used light as a dynamic element in his work beginning in 1923, Tatlin used movement as a principle in his *Monument to the III International* of 1919-20, and the architect Georgy Krutikov transferred constructivist ideas to mobile architectural complexes floating in space.[29] Tatlin and Petr Miturich, too, were close to the kinetic method in their projects for flying machines.

The Moscow kineticists belong to the constructivist tradition precisely in their *application* of theoretical idea to a practical function. Nusberg tried to do this in his project for his Alice in Wonderland Pioneer Camp and his layout for a Museum of the Soul. Infante also applies his designs to environments that, at present, are less feasible, as his incredible *Necklace* project (intended to encircle the Earth) demonstrates. This utilitarian aspect of the Moscow kinetic work distinguishes it from parallel trends in other European countries. In Poland, for example, Jan Chwaczyk has created light constructions; in Czechoslovakia, Dalibor Chatrny, Karel Malich, and many others work in a constructive idiom; but the essential idea of a kinetic artificial environment predestined for the space era is absent from their work and it remains as "aesthetic" as the happenings of Western Europe and America.

## Conclusion

The Moscow kineticists promise much, perhaps even a resurgence of Russian art, although they tend not to use the word "art." The clarity of their vision and their future potential separate them from the other contemporary artists of Moscow. As indicated above, much of the work undertaken by the unofficial painters and sculptors is conventional, at least in form, and repeats the methods of surrealism, expressionism, and pop art. Even though the artists' search for a more mystical, subjective interpretation of reality does, in itself, constitute an ideological and social protest, the result is often a quaint confusion of established styles. One reason for this is that many unofficial artists are manipulating a political condition in order to create an artistic idea, at best a very uneasy procedure. Once the political relevance is withdrawn, their art is neutralized.

The current official endeavors to mollify dissident artists by allowing their exhibitions, by inviting them into the Union of Artists, and by acquiring their works for the reserves of the Ministry of Culture — such measures are, indeed, defusing the charge of much unofficial art. This is one more reason for assuming that the only valid art of Soviet Russia will be neither Soviet nor Russian but will transcend political and national barriers.

## Notes

[1] "Oskar Rabin o svoem tvorchestve" in *Tret'ia volna,* No. 2 (Montgeron, France, 1977), p. 91.

[2] A. Zhdanov's speech at the First All-Union Congress of Soviet Writers, Moscow, 1934. Quoted from I. Luppol *et al.,* eds., *Pervyi vsesoiuznyi s'ezd sovetskikh pisatelei* (Moscow, 1934), p. 4. Gorky's speech, *Ibid.,* p. 13.

[3] *Ibid.,* p. 4.

[4] Reproduced on the cover of *Iskusstvo,* (1973), No. 4.

[5] *Barachnye Khudozhniki.* The word *barak* (adjective: *barachnyi*) signifies not only "barracks" but also, specifically, the squalid communal apartments jerry-built during the Stalin years for the workers' districts of Moscow and Leningrad.

[6] See R. Etiemble, "Pictures from an Exhibition" in *Survey,* No. 48 (1963), pp. 5-18.

[7] "Khrushchev on Modern Art." Stenographic report in *Encounter,* No. 115 (1963), p. 102-3.

[8] Quoted from J. Willett, *Expressionism* (New York, Toronto, 1970), p. 205.

[9] I. Popov, "Novatorstvo istinnoe i lozhnoe" in *Iskusstvo,* No. 11 (1968), p. 2. For Serov's statements see *V bor'be za sotsialisticheskii realizm. Sbornik statei i rechei V.A. Serova* (Moscow, 1963).

[10] Quoted from T. Whitney, *The New Writing in Russia* (Ann Arbor, 1964), p. 19.

[11] *Pravda* (March 15, 1963).

[12] This painting has been reproduced several times, for example, on the cover of Igor Golomshtok and Alexander Glezer, *Unofficial Art from the Soviet Union,* (London, 1977).

[13] C. Tisdall, untitled review in *Arts Guardian* (of *The Manchester Guardian,* January 19, 1977), p. 8.

[14] V. Nekrasov, untitled poem in M. Shemyakin and C. Kuzminsky, eds., *Apollon* (Paris, 1977), p. 65. I wish to thank Mr. Kuzminsky for this reference.

[15] *Barachnaya Moskva.* See Note 5.

[16] A. Glezer, "Russkoe neofitsial'noe iskusstvo v Evrope i doma" in *Tret'ia volna,* No. 2 (1977), p. 52.

[17] A. Shevchenko, *Neoprimitivizm* (Moscow, 1913). Quoted from J. Bowlt, *Russian Art of the Avant-Garde: Theory and Criticism 1902-1934* (New York, 1976), p. 46.

[18] Quoted from A. Breton, "Pourquoi nous cache-t-on la peinture russe contemporaine?" in his *Le blé des champs* (Paris, 1967), p. 322.

[19] E. Moiseenko, "Traditsii i poisk v iskusstve" in *Iskusstvo,* No. 4 (1977), p. 4.

[20] O. Tselkov, statement in Golomshtok and Glezer, *Unofficial Art from the Soviet Union,* p. 159.

[21] V. Nemukhin, statement, *Ibid.,* p. 152.

[22] V. Kandinsky, "Kuda idet 'novoe' iskusstvo" in *Odesskie novosti* (Odessa, February 9, 1911).

[23] "Nash prolog" (unsigned but probably by Chekrygin) in *Makovets,* No. 1 (Moscow, 1922), pp. 3-4.

[24] O. Tselkov in Golomshtok and Glezer, *Unofficial Art from the Soviet Union,* p. 159.

[25] P. Filonov, "Deklaratsiia 'Mirovogo Rastsveta'" in *Zhizn' iskusstva,* No. 20 (Petrograd, 1923), pp. 13-14.

[26] "Lev Nusberg und die Gruppe 'Bewegung'" (unsigned) in catalog to the exhibition *Progressive russische kunst/Lev Nusberg und die moskauer gruppe 'bewegung',* Galerie Gmurzynska (Cologne, 1973), unpaginated.

[27] F. Infante, *O kineticheskoi srede i metode sozdaniia kineticheskikh proizvedenii primenitel'no k praktike kineticheskikh sred-vystavok i nekotorykh proektov* (unpublished manuscript), p. 4.

[28] F. Infante, "An 'Architecture' of Artificial Systems in Cosmic Space" in *The Structurist,* No. 15/16 (Saskatoon, 1975/1976), p. 60.

[29] On Krutikov see S. Khan-Magomedov, "Proekt 'letaiushchego goroda'" in *Dekorativnoe iskusstvo,* No. 1 (Moscow, 1973), pp. 30-36. It is of interest to compare Krutikov's theories with those of Koleichuk. See V. Koleichuk, *Mobil'naia arkhitektura* (Moscow, 1973).

# 2 Two Decades of Unofficial Art in Leningrad

Constantine Kuzminsky

The contemporary, so-called unofficial (or nonconformist) art of Russia is not an avant-garde art. It would be hard to expect something really new to appear in a country where all art was destroyed, physically, for two decades (1933-53) and ideologically for the ensuing twenty-odd years. But, like a river, art went underground, to reappear a quarter of a century later. This art had no practicing teachers, no studios, no good quality brushes and paints, no customers, and finally, no viewers; but it shared something with the Russian avant-garde art of the distant past—spirituality.

In contrast to Moscow, where painting reigned, Petersburg was famous for its graphic art. This relationship between painting and graphics still exists today. In contemporary Petersburg (as in the Baltic countries) a graphic view of the world predominates. It is no accident that one of the few teachers in Leningrad turned out to be a famous graphic artist of the twenties, later a producer in the Comedy Theater, Nikolai Akimov. After Stalin's death, a department of stage design in the Leningrad Institute of Theater, Music, and Cinematography was opened and directed by Akimov. Graduates included Mikhnov-Voitenko, Tselkov, Tiulpanov, Dyshlenko, Rapoport, Kubasov, Mikhailov, Kulakov, Azizyan, Kochergin. And all this was the result of one man's work. Alek Rapoport, now an emigre in San Francisco, writes to me about Akimov:

> In his composition course, Nikolai Pavlovich used to make use of the accomplishments of VKhUTEMAS and VKhUTEIN (Higher Artistic-Technological Schools) and of the Western avant-garde. Having traveled extensively, he acquainted us with the best museums in the world through beautiful slides. The scope of his interests was broad, ranging from Vermeer to Dali. He could not stand the impressionists and abstractionists; the former for having begun the destruction of form, the latter for having completed it. [Note that among his students were the brilliant abstractionists Mikhnov-Voitenko, Kubasov, and Kulakov—Author.] A good understanding of architecture and Constructivism was another strong aspect of his work. Akimov was master in his own department and allowed nobody to meddle in his affairs. All formal exercises were permitted. Any style, any experiment was encouraged . . . . In this was his strength, thanks to which such a varied group of artists graduated from his department . . . .

But, alas, there are not enough Akimovs to go around. The 1950s generation of artists can be characterized as fatherless. They were chased out of all the artistic institutions of the country, and most of them had only a secondary artistic education (the famous Middle Artistic School). Nevertheless, this generation not only created its own style, if not its own direction, but produced artists now known abroad, such as Mikhail Shemyakin.

## Two Generations

The groups that were created in the 1950s were spontaneous and friendly in character, uniting artists of diametrically opposed tendencies. Thus, the following artists took part in one of the first apartment exhibitions in 1959: Elinson, a surrealist with a tendency toward the Filonov school; Rokhlin, a surrealist of a more Western type; Tovbin, who created black and white graphic abstractions and later went into architecture; Nikolashchenko, a tachist, now involved in his reliefs and counter-reliefs; and, slightly later, the marvellous poet Alekseev with his landscapes. In all, a rather usual "cocktail" for Leningrad exhibitions. All the participants were individually called into the KGB where they were exhorted and warned not to do formalistic work.

By the sixties the artists felt hemmed in and searched for viewers. During Khrushchev's "thaw," with the help of the technical intelligentsia (engineers, students, doctors, and scientists), exhibitions were arranged at institutes, youth cafes—anywhere space could be found. Usually such exhibitions closed on the second or third day, sometimes with a scandal, but always with the participation of the KGB. In the spring of 1964, there was an exhibition at the State Hermitage Museum, where the artists Shemyakin, Ovchinnikov, Lyagachev, and the poets Ufland, Saburov, and I worked as custodians and stevedores. The exhibition was opened with the permission of the assistant director of the Hermitage, V.P. Levinson-Lessing, and was closed on the third day by order of the KGB. All the works were confiscated; all the participants were fired. For almost seven years the artists were silent. At the end of 1971, a provocative underground exhibition was organized on Kustarny Pereulok in a cellar studio of some unknown person. The organizers were Turovsky and Ovchinnikov. The exhibition went on for three months. It was one of the freest of exhibitions.

In the 1960s and 1970s, many unofficial artists were able to obtain for their use various nonresidential spaces (attics, cellars, garrets), allowing them to paint in studio conditions and giving them the opportunity to meet each other and their audiences. The space was obtained through the City Committee of Artists, an organization which united professionals who did not belong to the Artists' Union. I must remind the reader that the rights to a well-equipped studio, as well as to the purchase of Dutch water colors, French brushes, German paper, etc., are the exclusive perquisites of members of the Artists' Union. The others had to draw on wrapping paper (Rotenberg), use aniline dye (Bogdanov), and steal paper (everybody). The authorities aim to bring everything under their control, including the means of production.

An unofficial artist must earn a living and often must find work outside art. In fact, such work is compulsory, for artists are threatened with exile to the North if accused of parasitism. In the sixties prices on pictures sold unofficially (which is against the law) were thirty rubles for an oil painting and about ten rubles for a drawing. Now the prices have gone up along with the demand, but the state is not asleep, and sales are still forbidden. At any rate, few of those who enjoy and view the works are able to buy. In Leningrad in the 1960s there were four collectors comparable to George Costakis, the officially encouraged collector of un-

official art in Moscow. These were mostly professors and academicians, but they were chiefly interested in the avant-garde of the 1920s and only occasionally in a particular contemporary painter. Thus, Academician Perfilov (known as the "one-armed bandit") assembled at the above-mentioned prices a rich collection of the works of the then starving Shemyakin.

This is a logical place to mention a uniquely disinterested collector in Russia: Father Alipy, abbot of the Pskov-Pechersky Monastery (in the past himself an artist, a battle painter of Grekov's studio, a captain of artillery, several times decorated, and a member of the Communist party, who became a monk after the war). In his collection, in addition to Murillo originals, the works of hundreds of totally unknown unofficial painters were assembled. After his death in the spring of 1975, the monks, with the benevolent help of the authorities, destroyed his whole collection (naturally, with the exception of the Murillos).

Hence, most of the works of the two hundred artists in Leningrad will never reach other viewers, particularly in the West. Even when they take their own work out of the country, emigrating artists have to pay a duty which is higher than the worth of the paintings. In this connection, the works are assessed by the Cultural Directorate and the employees of the Russian Museum but naturally they are not accepted by the Russian Museum or any other. In addition, there exists a list of the more interesting artists whose works may not be taken out of the country. All this makes it almost impossible for Western viewers to acquaint themselves with the work of contemporary Russian artists. Collections existing in the West (such as that of Alexander Glezer in Montgeron, France) are for the most part put together on the basis of availability rather than the level of excellence or artistic direction. Generally, Western collections are something for the future (if they ever come about).

**The Last Three Years**

The peak year for exhibitions of unofficial artists was 1974. The developments ran parallel in Moscow and Leningrad because of contacts among the leadership, but only the Moscow events received publicity. Foreign consulates opened in Leningrad only in 1973, and correspondents were unheard of. As early as the winter and spring of 1973, exhibitions and poetry readings were organized at Leningrad University (in Count Bobrinsky's mansion on Galernaya Street, now Krasnaya Street). The first artists exhibited were Ross, Putilin, and Glumakov. I gave talks. The week-long exhibition attracted, in addition to students, many artistic young people, and ran its course peacefully. The next exhibition, *Graphics and Photography,* with thirteen participants, was closed down the second day for demonstrating work of a pop art character.

At the end of August, 1974, preparations started for exhibiting a group of Leningrad artists at my apartment. By coincidence, this exhibition opened on September 15, simultaneously with the famous "bulldozer" exhibition in Moscow. Twenty-three artists participated, showing 128 works—oils, sculpture, and graphics—in an area of twenty-four square meters. Conceived for a narrow circle of friends and possible collectors, the exhibition attracted over eight hundred viewers during the week, including a number of diplomats.

A strictly enforced "dry law" (at the insistence of the proprietor, an alcoholic) and also the observance of quiet and order gave the militia no excuse to interfere in this exclusively private affair. Among the exhibits were abstract works by Mikhnov-Voitenko, Bogdanov, Galetsky and Vinkovetsky; metaphysical works by Vasiliev, Lyagachev, and Gennadiev; primitivist paintings by Gavrilchik; surrealist works by Ross and Putilin; impressionistic watercolor landscapes by Timofeev; graphics by Dyshlenko, Petrochenkov, Sazhin; sculpture by Bersudsky and Voronova. The architects Telov and Tovbin showed their paintings. Youth was represented by Belkin, Isachev, and Shipkin. The host had the nerve to exhibit works "bearing the character of pop art." The participants ranged in age from about thirty to forty-five; eighteen had artistic education (middle and higher). One participant removed his work out of fear of the consequences. Actually, there were no consequences.

The first official exhibition of unofficial artists (the first indoor one in Russia and the first exhibition of nonsocialist realists in thirty years) took place in Leningrad from December 22 to December 25, 1974. This exhibition was a result of the activities of all the artists—the creation of an organizational committee, official correspondence with the authorities—but mainly it resulted from the echoes in the West after the Moscow events, the disruption of *The First Autumn Open-Air Exhibition* in mid-September, 1974. The use of bulldozers as a means of countering undesirable artistic currents was a novelty for the West.

Order within the exhibition was kept by the artists themselves, but the crowd of many thousands at the entrance was controlled by the clubs of the reinforced militia. The opening of the exhibition was not announced by the press, radio, or television. There was only one notice at the entrance itself. However, this did not prevent fifteen thousand people from visiting it in four days. The Gaz Palace of Culture, located in the workers' suburbs, was provided by the authorities for the exhibition. Fifty-three artists took part; 206 works were exhibited. A democratically constituted organizational committee, made up of the artists themselves, selected the works. Works of amateurs as well as professionals were chosen.

The strongest impression was made by the school of V. V. Sterligov. The Sterligov Collective owes its existence to Vladimir Vasilievich Sterligov who died in 1973, a student and follower of the suprematist Malevich, who introduced a brilliantly expressed religious theme into the geometrical trend. From 1934 to 1944, Sterligov, together with the artist Basmanov, was in the labor camps; both were sentenced in connection with Kirov's assassination. After leaving the camps he, together with his wife T. N. Glebova, a student of Pavel Filonov, had only one one-day exhibition in the Artists' Union building (at the end of the 1960s), and one posthumous exhibition in 1973. He had no studio. Both he and his wife lived and worked in a tiny two-room apartment belonging to a relative. Despite these conditions he attracted a whole school of students and followers in addition to creating wonderful tempera-collage paintings (or, as he called them, "bathages"). Religious themes are absent from the works of his students, and formal elements are dominant. These artists are Zubkov, Smirnov, Solovyova, Kozhin, and others.

In general the religious (Orthodox) theme is expressed weakly in Leningrad painting, although many of the artists (if not the majority) are deeply religious people. Religion is a secret thing in Russia, as it was in the first centuries of Christianity. I have only seen one person wearing a copper icon on his chest, although the artists' connection with the church is commonly observed. The theme often appears as dilettantish speculation (V. Filonov) or contrived primitivism (in the figurative painting of Vinkovetsky). It is present in the work of the metaphysical school in enciphered form. The

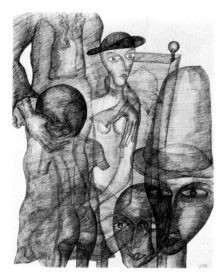

19. Igor Ross. Untitled, 1976. Mixed technique on paper, 28 x 28 cm.

18. Henry Elinson. *Family Portrait,* 1972. Ink drawing, 48 x 36 cm.

20. Oleg Lyagachev. *Composition,* 1974. Tempera, 35 x 30 cm.

theme of the crucifixion is expressed with special vividness in the work of Yuri Zharkikh.

The collapse of the Leningrad unofficial movement dates from the spring of 1975. The authorities switched from intimidation to concrete action. Thus, before the exhibition planned for May, Zharkikh, leader of the Leningraders, was "knocked out of the line" by three months of hospitalization. Differences also arose among the artists. A small group led by Sinyavin separated itself from the fifty-three participants in the Gaz Palace of Culture exhibition. Against the decision of the participants to compromise with the authorities for the sake of a promised exhibition in September of that year, this small group demanded immediate action, coming forth with slogans almost political in character. On the whole, however, the artists' movement did not pursue any political goals, limiting itself to the rights guaranteed in the Constitution of the Soviet Union. The artists even agreed with the authorities' demands not to exhibit works of a political, religious, or pornographic content, defending only the right to include artists of all directions and the right to choose the works to be exhibited themselves. The September, 1975 exhibition took place at the Neva House of Culture (even further from the center of the city) and displayed the works of as many as eighty-seven artists. New artists were present, including Igor Tiulpanov.

Later the movement disintegrated into a number of separate groups, which exhibited their work wherever they could—in clubs, in apartments. The apartment that lasted longest, for more than a year and a half, was that of a talented physics teacher and art collector, Mikhailov. Beginning in February, 1975, the works of several dozen artists, mostly the participants of the first exhibitions, were displayed there. The authorities continued to blockade the apartments of the participants, to threaten and persuade; but the artists wanted to be exhibited, and the viewers wanted to look.

In May, 1976, the second leader of the Leningrad artists, Evgeny Rukhin, thirty-two years old, "left the ranks." He perished under mysterious circumstances. The investigation of his death turned into an interrogation of artists by the militia and the KGB, interrogations having nothing to do with Rukhin's death. An attempt to arrange an exhibition in memory of the fallen comrade was roughly cut off by the authorities. The artists were arrested or detained by the militia at the approaches, and three poets (Yulia Voznesenskaya and the Gun couple) who had reached the walls of the Peter and Paul Fortress (the place of the exhibition) were arrested right there.

After this there was nothing to do but to keep quiet (which the authorities counted on) or to switch to active measures. In August, 1976, two artists (Volkov and Rybakov) were arrested in connection with slogans about creative freedom which appeared on the walls of the Peter and Paul Fortress. They were detained under investigation for more than six months and sentenced to six and seven years in the camps. The authorities were ridding themselves of the more active and dangerous elements. One of the leaders of the movement, Sinyavin, was let out of the country, and his co-author in a project for a collective anthology of poets and artists, Yulia Voznesenskaya, the mother of two children, was given five years in exile. Sinyavin is now in New York, while Voznesenskaya is in Vorkuta.

Actually, such a situation came as no surprise. In beginning the fight for rights—this time the rights of artists—the majority had long ago been prepared for the worst. In January, 1976, the leader of the kinetic art collective, Lev Nusberg (who also started in Leningrad), wrote me:

Dear Brother: Light a candle. Pray to God. The frost, since you left, has become horrible. On 15 January 1976, in the Main Directorate of Culture, a directive was read to us (by *four old ladies*), promulgated on the basis of a decision of the Council of Ministers made in December,

1975. The directive contains the policies on exhibitions for 1976. That little Point No. 2 of the earlier directive, on the basis of which our two exhibitions (Gax and Neval) somehow sneaked through, has been abolished. All exhibitions will be conducted *in light of the decisions of the XXV Party Congress,* and are required to glorify the heroes of the ninth Five Year Plan. We were invited to "kindly" take part in these poisonings. At the Ministry and its chief administrative office, special commissions with broadened powers for the acceptance and organization of all exhibitions have been created.

And I say to the old lady, that as an artist I must not be guided in my activities by their social-artistic demands. To which she says, "We have a Party art, everything is Party, and if you don't like it get out and look for something else." And at this she grows savage, trembles all over, and it's as if a commissar's leather coat with revolver appears on her.
Sasha Leonov [a member of the initiative group of Leningrad artists. . . .] says, "I'll do just that to her." He has a summons in his pocket. Another old lady tells him: "You are pretenders and we will not recognize you. Your initiative group is nothing to us."

In answer to a letter addressed to the Oblast Committee of the Party, requesting the organization of a painting section at the City Committee of artists . . . the KGB conducts a purge of the City Committee. Sasha Okun is thrown out of his job in the artists' school for taking part in the Jewish exhibition in December 1975 (in Moscow, at Aida Khmelyova's apartment). A directive is being prepared forbidding the private sale of work. *Our last teeth are being knocked out.*

Looking back (and one does not want to look forward), the entire movement can be divided into three periods:
(1) 1953-1964 (before the sadly famous exhibitions at the Manege and the Hermitage). The first generation of artists. The reopening of the accomplishments of the Russian avant-garde and familiarization with the contemporary art of the West. Various (not very significant) exhibitions in cafes and apartments. The flowering and (in the 1960s) the disintegration of the group of Arefiev, Vasmi, Shvarts. The work of this group is characterized by "anti-Stalin" aesthetics, de-heroization, expressive realism ("street" subjects), restraint of colors, simplification of form. They are close to the Moscow barracks poets Kholin, Sapgir, and, among the artists, Rabin. The appearance of Akimov's students, Mikhnov-Voitenko, Delkov, Tiulpanov, Dyshlenko. Interest in the works of Pollock and the surrealists. The founding of the kinetic group "Movement" at the apartment of the philosopher Ponizovsky. (The founder was Lev Nusberg, who later moved to Moscow. The continuation and development of the traditions of Tatlin and Malevich.

(2) 1964-1974. Most of the artists enter into serious studio work. The appearance of the second generation of artists (Shemyakin, Vasiliev, Lyagachev—the metaphysical school). The appearance of metaphysical synthesis (Shemyakin, Ivanov), its connection with the Moscow artists of the older generation (Shvartsman, Tyshler), its development as a direction. Shemyakin's departure for Paris (1971). Since 1971, bohemian exhibitions at the Ozerki and on Kustarny Pereulok. The KGB begins to take a serious interest, not yet in painting but in painters.

(3) 1974-1977. The flowering and disintegration of the mass movement of artists. Division into groups; the appearance of national exhibitions (exhibitions of Jewish artists in Moscow and Leningrad). The beginning of mass emigration and expulsion of the artistic intelligentsia from the country. Half the leading artists of Leningrad leave (Arefiev, Leonov, Abezgauz, Lyagachev, Rapoport, Elinson, Brui, and many others). Physical persecution and arrests of those who remain (Volkov, Rybakov, Filimonov); the death of Rukhin. Zharkikh leaves for Moscow. The artists are left without leaders, and their ranks have been thinned.

It is unpleasant to look into the future. There is no hope of any kind. I am afraid that this first (though far from complete) exhibition of Russian unofficial art will turn out to be the last one. The art of three generations will remain, in attics and cellars, with nobody to collect it, anonymous, inaccessible. It is the second ruined body of Russian art.

# 3 The Avant-Garde in Soviet Estonia

Stephen C. Feinstein

When one compares recent developments in the contemporary art movement in the Estonian Republic with the official and unofficial art movements in other regions of the Soviet Union, the distinctiveness of Estonian art is evident. The movement exists in the open with strong support from the local population and with the apparent consent (or lack of overt opposition) of the Estonian Communist party. The movement itself has changed from its "unofficial" status in the early 1960s to its current "official" or "semiofficial" status (depending on precise conditions of the time in question), without sacrificing experimentation and creativity. The result has been the formation of a well-defined national school of avant-garde art, strongly oriented toward graphics but developed in other areas of artistic media as well.

The distinctiveness of Estonian art is not limited by its official designation. Most of the artists who identify with the avant-garde graduated from Tallinn's Art Institute. Since 1964, art exhibitions have been held in the galleries of the Union of Artists and Tartu University rather than in private apartments, as was characteristic of many exhibitions in Leningrad and Moscow. Catalogues published in the aftermath of each exhibition have provided a historical record of the event and have encouraged a scholarly examination of the experimental forms. The Estonian artists have also managed to publish two official journals. The first, *Kunst,* is edited by Tonis Vint and has appeared semiannually, with some long delays and interruptions because of censorship or printing problems. The covers of *Kunst* boldly pronounce the modernist and strong constructivist influences on the local artists. The articles in this journal are more than bland statements of art history or contemporary developments. Recent articles have dealt with such themes as "Three-Dimensional Art Expression," "The Architecture of Louis Kahn," "Aubrey Beardsley's Extraordinary World," "Hyper-realism and the Artificial Environment," fantastic realism, and criticism and evaluation of local developments.

The second Estonian art journal, *Kunst Ja Koda* (Art and Life), gives the local populace a more complete understanding of modern art and its relationship to art currents in other countries. Modern architecture and the decorative arts take a dominant place in this journal, suggesting the dynamic influences of neighboring Finland. The Finnish influence as well as the history of Estonia before 1940 cannot be underestimated when evaluating the contemporary art scene there. During the period of independence after World War I, Estonian artists developed their own expressionist and constructivist motifs and maintained close intellectual ties with artists to the East and West. More recently the Estonians have benefited from the television broadcasts they receive from Finland. Many of Finland's decorative traditions have obviously spilled over into the Estonian way of life.

The overwhelming visual characteristic of the Estonian avant-garde is its dedication to the use of graphic design. The Estonian artists seem to realize the uniqueness of their utilization of graphics, with or without color. In a 1972 issue

of *Kunst,* Mai Levin, a local Tallinn art critic, wrote that "it is desirable that our graphics should build technical differentiation while continuing sensitive and experimental traditions."[1] Whether working in the medium of pen and ink, gouache, intaglio, lithography, or oil and water color painting, all of the Estonian artists represented in recent shows have displayed technical perfection in their draftsmenship. Artists like Tonis Vint and his wife Mare, Leonhard Lapin, Malle Leis, Raul Meel, Kaisa Puustak, Siim Annus, and Urmas Ploomipuu are but a few of the Estonian avant-garde known for their technical perfection in drafting and unique subject matter in their artistic production. For example, at the *Biennial of Graphic Art Exhibition* held in Ljubljana, Yugoslavia during June-August, 1975, two-thirds of the Soviet artists represented were Estonian. In the *Biennial Exhibition of Prints* held in Tokyo earlier in 1975 the Estonians were well represented.

## Vint and Reconstructivism

A poster for the 1975 Tallinn show used the provocative title of *Rekonstruktsioon* (Reconstruction), suggesting a revival of the tendencies of the constructivists of the 1920s. While the Estonian avant-garde is too wide in its intellectual base to demand an overwhelming allegiance to a single ideological doctrine like constructivism, the revival of older experimental forms from the native Estonian as well as the Russian and West European traditions has been useful for nurturing the modern movement. For example, Tonis Vint has stated that he views ideology in art as destructive and therefore uses constructivism only as a basis for graphic design and experimentation in form. From the study of the constructivists, Vint sought to pose a series of new artistic and intellectual problems for the art community. Vint also revived interest in the study of the Estonian artists Arnold Akbers, Mart Laarman, and Eduard Ole, each of whom was known in the 1920s for his experimental art. Vint later stumbled upon a copy of Yakov Chernikhov's *The Construction of Architectural and Mechanical Forms,* which opened new doors for the study of the Russian constructivists. To these Vint added the study of the work of Ulo Sooster, whose death in 1970 ushered in the study of fantastic realism (fig. 21).

Vint says that he received great intellectual stimulation by examining the works of Joseph Hoffman, an early twentieth-century Viennese painter, the works of Frank Lloyd Wright, Aubrey Beardsley, and the artistic designs of Japan from the Shinto period.

Tonis Vint's early graphic works, dating from 1968, convey the constructivist notion of geometric rationality. Using pen and ink or gouache, Vint embarked on the production of a series of constructions which sought to analyze the basic problems of spatial relationships of different geometric forms to each other. As he developed a degree of harmony in these exercises, Vint introduced new elements of conflict. The first such impositions were new geometric forms which added color or shape contrasts to the basic

21.  Ullo Sooster. *Machine and Nature*, 1965. Pen and ink.

22.  Tonis Vint. *Construction*, 1972.
     Pen and ink, 20 x 20 cm.

23.  Tonis Vint. *Construction with Nude*, 1974.
     Gouache, 36 x 36 cm.

square-triangle-circle structure of the works. For example, a number of his drawings showed "nervous dots" (fig. 22), as he called them, moving across the paper and creating a tension with the geometric harmony which had been established previously. The same tension was produced with the imposition of cruciform patterns in various sections of a geometric plan. These graphic works have an interesting appeal as they display a complex philosophical view of constructivism and its problems. At the same time, the pen and ink medium provides for a simplicity of form and compactness. In these drawings, Vint also established his ability to permit the whiteness of the paper itself to play a substantial role in creating visual balance. All of the drawings of this period suggest a statement on the notion of order via geometric symmetry and freedom in the form of the intruding forces.

From his purely technical drawings Vint introduced sensual, Beardslian, nude; female figures into the fabric of the constructivist motifs, with a sharper black on white contrast. The figures are striking, perhaps disarming at first glance. A further analysis of the structure of the work, however, shows the delicacy of planning and articulation of the drawing, and the fundamental conflicts which are raised by the combination of the sensual with the geometric (fig. 23). The introduction of these striking sensual elements raises the question of the relationship between the two forces in Vint's works: one force is human and sensual, the other geometric and precise. On a philosophical level, one is forced to ponder which force is alien—the female figure or the construction itself. It seems difficult to conclude that the two can exist side by side as the conflict seems too open and hostile. The use of a stark black on white neutralizes extraneous elements to create a drawing with an iconlike form and the technical perfection of oriental art. The tensions in the work are not hidden but placed in a clear relationship to one another.

The influence of Aubrey Beardsley on Vint's works is clear. Vint has written an article on Beardsley's life and work in *Kunst* and noted that "Beardsley succeeded in filling out white paper like no one before him."[3] The black on white contrast, the figures of the women, and the oriental influences can possibly all be attributed to Beardsley.

The boldness of Vint's expression has not been without repercussion. On more than one occasion, the charge of pornography has been leveled at the artist's work. In the February, 1974 issue of the Estonian youth magazine, *Noorus*, two pages containing Vint's nudes were removed by hand from 36,000 copies of the run.

### The Engineering Aesthetic

Leonhard Lapin's artistic vision is more closely allied to the utopianism of the early constructivists (fig. 24). An architect by training, Lapin has written:

> The basic problem of creation
> the unity of the different
> qualities of existence
> a part of the new inorganic
> world—the world of machines
> —in this system[4]

Lapin's oils and lithographs are bold and daring, using deep color contrasts with constructivist and pop art themes. Displaying the same technical perfection as Vint (and other Estonian artists) Lapin has ignored totally any romantic or realistic visions and has instead portrayed a world of conflict where the only rational elements are the pure geometric forms. Violence appears in varying ways: the imposition of the constructions upon a neutral canvas; the appearance of blood or fire, bullet wounds or explosions on constructions and human forms alike. In these works, the organic elements appear to bow to the power of the inorganic. Lapin has executed this theme most successfully in a series of lith-

32

24. Leonhard Lapin. *Machine X,* 1975.
Stereotype, 40 x 38 cm.

25. Leonhard Lapin. *Woman-Machine XIII,* 1976.
Stereotype, 40 x 38 cm.

26. Malle Leis. *Woman and Red Horse,* 1974.
Oil on canvas.

ographs which begin as academic demonstrations of spatial relationships between lines and circles. Like Vint, Lapin adds the female torso to the construction. However, Lapin's end product becomes infinitely more violent and erotic than Vint's composition (fig. 25). In these drawings, the female torso loses its subjective humanity from the point of view of the artist to become another of the compositional elements. However, at the same time, the viewer cannot give up his traditional recognition of the sensuousness of the female anatomy. The result, therefore, is that the geometric elements become the symbolic devices of sexual abuse. Yet, there is always a plausible alternative, as illustrated in Lapin's quadrapartite lithograph showing a female torso with legs spread, experiencing sexual pleasure or abuse from a penislike geometric object, surrounded by black and white circles in a bubblelike pattern (fig. 88). As one proceeds from top right to top left, to bottom right and left, the penislike object is rotated to suggest the sexual act itself and the pleasure/abuse connected with that act. In the final quadrant, however, the torso itself disappears, to be totally devoured by the geometric elements. Taken individually, this quadrant gives no hint of the violence connected with the prior three squares. Yet, at the same time, it may be suggested that Lapin has in this drawing successfully integrated the physical as well as the emotional aspects of the sex act. For example, one is led to wonder if the first three quadrants represent the physical aspects of lovemaking, while the fourth is the consummation of the act.

In any case, there is something unique in the creations of both Vint and Lapin. Both artists have moved from an elegantly simple geometric foundation into an erotic motif. Both have managed, however, to create artistic works with substantial tension and eroticism in a constrained artistic environment. The fact that these works were executed and displayed in the Soviet Union is a remarkable testament to

the independence of the Estonian artists and to the different levels of "game rules" for unofficial and official artists in different parts of the USSR.

It is not too difficult to suggest, without detracting from the uniqueness of Lapin's contribution, that his work and theoretical approach to art is reminiscent of the constructivist rules established by El Lissitzky in the 1920s. For example, in 1929 Lissitzky wrote that:

> The intrinsic nature of art reveals itself through ordering, organizing and activating consciousness by emotional energy charges . . . . For this reason it is not enough to be "modern;" on the contrary, it is necessary for the architect to gain command of all the means of expression that relate to the art of building. [5]

It would appear that Lapin is in full agreement with such sentiment as indicated in his journal articles on the historical aspects of Estonian architecture and recent experimental design. Lissitzky's influence here should not be underestimated.

Raul Meel's prints belong to a purely abstract aesthetic, probably related to his engineering background. His poster for the *Third Tallinn Triennial Graphics Exhibition* of 1974 and his series *Sous le Ciel Estonien* (fig. 54) lack the disturbing violent and emotional overtones of Vint's and Lapin's work. His arrangements of lines and colors are based on mathematical proportions rather than human images or even mechanical and architectural forms. Of all the Estonian artists, Meel best exemplifies the qualities of self-sufficiency and detachment.

### Malle Leis and the Sense of Color

Malle Leis, unlike the previous artists, does not offer the strong influence of constructivist forms. The focal point for her art is nature with a particular emphasis upon the ornamental and rhythmical effect of flowers. Her works depict

a microscopic segment of a greater area, deliberately removed from the realm of the realistic to become a work of abstraction. The artist has been strongly influenced here by the *hua niao* form of painting from Chinese art with its emphasis on flowers and birds to which Leis has added small beetles. Interpreted as a fragment of real life, the canvas loses its previous relationship to nature.

All of Leis' compositions are well defined and made to stand out against opaque backgrounds. Therefore, these natural elements can be perceived from the point of view of color alone, uncluttered by the natural surroundings. Color is intensified by deep tones, which the artist has maintained even in her serigraphs by hand screening twelve to eighteen layers of a mixture of oil and tempera which she has devised. This has produced a unique layering effect which gives an illusion of an oil painting to the silkscreen prints (fig. 53). While Malle Leis seems to emphasize natural elements in contrast to Lapin's and Vint's constructions, all three artists nevertheless appear to be on similar tracks. A close analysis reveals the similarity of purpose in the ultimate desire of each artist to achieve a synthesis of elements giving rise to a new artistic form. In the case of Vint, the human and geometrical constructions stand in symbolic relationship to each other. In the case of Lapin, the subjective elements are perpetually in conflict. In Malle Leis' flowers, an independent iconographic reality is created by use of bold colors, sharply contrasting to each other, with the insects providing a bit of mystery.

Leis' art is similar to that of Vint and Lapin in another distinctive way, which is perhaps a universal characteristic of the Estonian avant-garde. All of the works are composed without reference to time or particular space.

In some of her recent works, Leis has interjected mysterious geometric or human elements which infringe upon nature and create conflict. A small red arrow appears to direct a bouquet of roses floating in midair. A hand intrudes upon a group of flowers, accented by purple line constructions from above. A girl appears to approach a red horse — or are both independent aspects of sensory or dream perception (fig. 26)?[6]

A recent development of the relationships between space and time is illustrated in Leis' large *Triptych*. A woman standing against a deep red background on the right side appears to gaze through an invisible window toward the left. In front of her, apparently outside of her frame of awareness, float a cluster of fruit and a purple tulip. The second panel shows two separate, more complex groupings of fruit, flowers, and insects. A thick line extends from the woman, cutting across this second panel into the third, which is empty but for three red beetles, which apparently migrated from the flowers in the middle panel. It seems that the artist has created both a depersonalized self-portrait and a series of mental images of the objects with which she works. Abstracted from any natural setting, these objects gain a new and vivid reality as objects of artistic regard, while the artist remains on a plane remote from the surface of the painting, as if temporarily subordinate to the art-making objects. The ambiguous relationship between depth and flatness and the controlled serial progression from right to left is related to the nature of the creative process. At the same time, there is a suggestion of the interplay between forms and emotion, much like the use of the constructions in the works of Vint and Lapin.

## Conclusion

Estonian art has a wide breadth. The basic treatment given above focuses only on a representative sample from the Tallinn group. However, it would be incorrect to suggest that the themes exemplified by the works of Lapin, Vint, and Leis are the total spectrum of the modernist movement. A good deal of Estonian art tends to be political, although not in the socialist realist sense. The *Estonian Graphic Exhibition* of 1973, for example, featured a number of works dramatizing the plight of modern man, his isolation, facelessness, ability to be manipulated, and his propensity for war. The works of Juri Arrak, Olev Soans, and Vello Vinn stand out for their unique thematic qualities. Arrak's *Room in the Morning* and *Room at Noon* showed one-dimensional silhouettes of human forms in a state of disarray or puppet-like poses; Soans' serigraphs of 1971 depicted various antiwar themes, such as an international road sign indicating "no tanks here" (visually) or headless generals. It would appear that the Vietnam War provided an excellent opportunity for artists from all over the USSR to engage in some overt criticism of capitalism and the United States while suggesting some subtle criticism of the Soviet system itself. Vello Vinn's series *Wings* depicted a giant automobile with wings reigning supreme over a society of graphically precise geometric housing and identically designed factories all belching smoke into the environment. Another work in the same series showed a faceless multitude gathered around a monumental cenotaph containing a gramophone. All of these works are visually and technically interesting, but at the same time are probably less effective than those of artists like Vint, Lapin, and Leis who use less politicized symbols in their works.

In the case of all of the Estonian artists, however, the viewer is immediately struck by the compositional qualities and the uniqueness of the subject matter. These works appear as a refreshing revelation that a creative art movement can exist in the Soviet Union under an "official" designation. At the same time, one is forced to speculate as to whether such bold developments can survive when "unofficial" artists in other parts of the USSR, who have engaged in similar experiments in technique and subject matter, have been forced to compromise their values in the face of official ideology.

## Notes

[1] Mai Levin, "Three-Dimensional Art Expression," *Kunst*, No. 42/2 (1972).

[2] Yakov Chernikhov, *Konstruktsiya arkhitekturnikh i mashinnykh form* (Leningrad, 1931).

[3] Tonis Vint, "Aubrey Beardsley's Extraordinary World," *Kunst*, No. 40/2 (1971), p. 11.

[4] From Lapin's *Vitae* (1975).

[5] El Lissitzky, *Russia: An Architecture for World Revolution* (1930; reprinted Cambridge, Mass., 1970), p. 70.

[6] Leis has stated that woman with a horse is an image from childhood, which she has recently developed in a way that emphasizes the disjunction and superposition of past and present.

# 4 From the Real to the Surreal

Janet Kennedy

One of the most striking things about the work of current unofficial artists in the Soviet Union is the large part of it that can be classified under the heading "surrealist." In fact surrealism comes close to being the dominant mode of unofficial art in the Soviet Union. In spite of the very individual features of such artists as Otari Kandaurov, Edward Zelenin, and others, parallels with Western European surrealism immediately strike the eye. This essay will highlight the work of a relatively limited number of artists—Kandaurov and Zelenin, Vladimir Rokhlin, Igor Tiulpanov, Ilya Murin, Petr Belenok, Oleg Tselkov, Vladimir Yankilevsky—but the list could easily be expanded to include others; for example, Nikolai Vechtomov, Mikhail Odnoralov, Vladimir Rykhlin, and Kuk. [1]

It must be stressed at the outset, however, that in grouping these artists together I in no way wish to suggest that there is such a thing as an organized surrealist movement in Moscow or Leningrad. The actual situation is in fact totally the opposite: each one of these artists works as an individual, they are in most cases unacquainted with each other, and some even seek a degree of isolation from the art world—refusing to affiliate themselves with any formal or informal grouping of artists. [2] Each one has an individual style; yet in each one some of the basic themes, images, or visual devices of surrealism make their appearance.

Surrealism in the West is a phenomenon that defies compact definition; however, the aim of the surrealist movement might be summed up in its advocacy of an "attack on reality." Surrealism calls for an enrichment of the world by means of the imagination. Historians of Western European surrealism commonly divide the movement into two wings—abstract and veristic. The former finds expression in biomorphic forms; that is, forms with an organic character, forms which appear to undergo the processes of flux, metamorphosis, growth, or decay. Veristic surrealism, on the other hand, depends on the imaginative spark produced by the juxtaposition of common objects taken out of normal context. Surrealist writers were fond of citing the well-known image of the Comte de Lautréamont in *Chants de Maldoror:* "As beautiful as the chance encounter of a sewing machine and an umbrella on an operating table."

## Moscow Metarealism and Surrealism

The influence of surrealist doctrine and imagery in the Soviet Union is immediately obvious in the work of Kandaurov and Zelenin, who stand at two different points in the spectrum of possibilities associated with surrealism. Kandaurov's painting *The Gravedigger* of 1967, with its bonelike yet strangely amorphous forms, its shadowy space dotted with half-familiar objects, falls into the abstract current of surrealism. The nearest stylistic parallel in the West would perhaps be André Masson or Yves Tanguy. Furthermore, Kandaurov in his "Metarealism; Creative Method and Creative Credo (Theses)" makes direct reference to the arch-surrealist Salvador Dali (and indeed seems to echo Dali's grandiloquent and deliberately obscure style of writing):

In compositions which are intended to express something equivalent to the revelations of the prophets, the requisite objects are assembled almost at random (as in a lottery), for the objective essence of things is consumed in the crucible of revelation . . .

The second method is the method of plastic mediation, i.e., the object is irradiated, as it were, by the light of spiritual bodies; its earthly flesh is refined; it becomes transparent; matter begins to flow and to be transformed into air. Dali's *Ecumenical Council* and *Columbo* and my own *Celestial Improvisations* offer different versions of plastic situations of this kind. [3]

Kandaurov's concept of metarealism thus encompasses both the abrupt and irrational juxtaposition of objects and the transposition of forms from solid matter into a fluid and transparent state subject to flux and metamorphosis. If *The Gravediggers* exemplifies the latter alternative—the "irradiation" of matter—Kandaurov's *Still Life,* 1963 explores the poetic possibilities of objects out of context, consisting as it does of an egg shape surrounded by rootlike forms (arranged, however, in such a way as to suggest a hollow skull). Kandaurov's work encompasses many different styles and subjects, ranging from personal and religious themes to officially acceptable portraits (one of his wife was in the officially sponsored *Russian and Soviet Painting Exhibition* at the Metropolitan Museum of Art, 1977). The *Portrait of Vladimir Nabokov* (fig. 27) combines an academic realistic technique with specialized references appropriate to Nabokov's writings. Because Nabokov's works are proscribed in the Soviet Union, this portrait was not accepted for the major *Graphics Union Exhibition* in Moscow in May, 1976.

Unexpected juxtapositions of objects are used with somewhat cooler, ironical effect in Edward Zelenin's painting. Zelenin's *Self-Portrait,* 1973 centers on a carefully delineated green apple of many times normal size, while the artist himself appears three times over reclining at the base of the painting in an "arty" pose which suggests simultaneously Michelangelo's *Adam* and a reclining odalisque. Another variation on the apple theme presents a monumental cut apple mysteriously crossed by a rainbow band and accompanied by a girl with an umbrella. It is difficult not to be reminded of René Magritte's *The Listening Room,* not only by the presence of the mysteriously enlarged apple in Zelenin's paintings but also by the immaculate precision of technique, which gives the paintings an exaggerated, hallucinatory clarity. Illogical and contradictory spatial effects are a major surrealist device, one present as well in Zelenin's painting. In his *Self-Portrait* the apparently solid ground plane suddenly transforms itself into bands of mist through which we see the spires of a medieval city. Here one might refer to Magritte's *The Field-Glass* for a similar betrayal of our spatial expectations.

In Zelenin's *Madonna* (1976) the traditional icon of the Virgin of Vladimir has metamorphosed into a mummylike figure, whose hollow form enfolds a series of multicolored

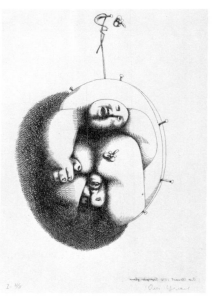

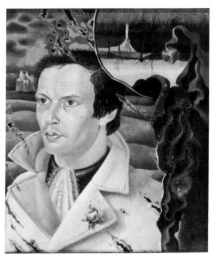

29. Igor Tiulpanov. Detail from *The Mystery*, fig. 63.

27. Otari Kandaurov. *Vladimir Nabakov*, 1975.
Mixed technique on paper, 51 x 36 cm.

28. Oleg Tselkov. *Double Portrait*, 1976.
Etching, 30 x 21 cm.

stripes. Where one would expect the softly modeled features of the Virgin, the eye is taunted with abruptly shifting patterns of line. In the background two cross shapes appear; normally a flat shape, the crosses here reveal a narrow strip of further space (apparently a view of the ancient churches of Vladimir, where Zelenin lived for several years). A final incongruous note is provided by the pomegranates floating in the foreground, their half-disintegrated look suggesting ripeness or fruition. Whether or not Zelenin was aware of the traditional association of the pomegranate with fertility, the forms and their placement have distinctly womblike connotations. The painting *Still Life with Pears* (fig. 136) contains related motifs. But the aggressively realistic depictions of objects are replaced by a new emphasis on a spatially ambiguous surface. The subtle monotone is broken by certain small, brightly painted areas such as the patterned hands, feet, and cowled head of the draped figure, or the butterflies, pears, and church cupola in the other painting. Zelenin's preoccupation with covering up objects in provocatively shaped folds of fabric, partially revealing details through gaps in the surface, and hinting at the presence of strange objects by means of shadows, seem to point to such classic surrealist works as Magritte's *The Lovers* or Man Ray's *Enigma of Isidore Ducasse*.

## Three Leningrad Surrealists

Leningrad appears to be a particularly strong center for surrealism of various types. Three noteworthy examples are Rokhlin, Tiulpanov, and Murin. Technically Rokhlin's painting has a slightly archaic flavor; he favors precise architectural backgrounds, clearly defined contours, subtle variations of light and shade in the modeling of forms, and deep browns and reds which bring to mind Italian painting of the late fifteenth century. Rokhlin's portraits of women appear to have been conceived with conscious reference to Leonardo's *Mona Lisa.* The resemblance lies not only in technique

but in the mysterious smile and dimly-lit spaces, aspects of Leonardo's painting which appealed to the French surrealists as well. Rokhlin's *Susannah and the Elders* (fig. 30) and his more anonymous female figures simultaneously invite and repel, combine the erotic and the disturbing.

Rokhlin has been working in his current style for a little over ten years. Like many unofficial artists his education was not in painting per se but in an art-related field — in Rokhlin's case at the Institute for Engineering and Building, where he majored in architecture. (He now works as an architect.) When asked to name the artists he admires, Rokhlin responded with the following list: Bosch, Botticelli, Van Eyck, Leonardo, Crivelli, and — oddly enough — Renoir. Except for the last, all belong to the fifteenth century. Visits to the Hermitage and study from art books have been important experiences for Rokhlin, Tiulpanov, and Murin.

An appreciation of the past is characteristic of many contemporary Leningrad artists. A fanatic devotion to a minute and painstaking technique based on that of the old masters seems to refute the whole idea of progress. A parallel situation is perhaps to be found at the turn of the century in the art of the *Mir iskusstva* group, which also found in past art a means for raising their technical level and for expressing disenchantment with the utilitarian values of the present.

There is no contradiction in combining an interest in past art with a surrealist orientation. Dali and others in the West deliberately opted for a conservative technique and would surely have approved, in general, Rokhlin's list of favored artists. However, the historical tendency of the artists under discussion becomes very nearly a theme in its own right for an artist like Tiulpanov. The work illustrated here, *The Mystery* (fig. 63), is a veritable compendium of imagery drawn from Dutch painting of the seventeenth century: the old man with eyeglasses, the monkey, the precisely detailed jewelry and vegetation. Tiulpanov's technique is meticulous

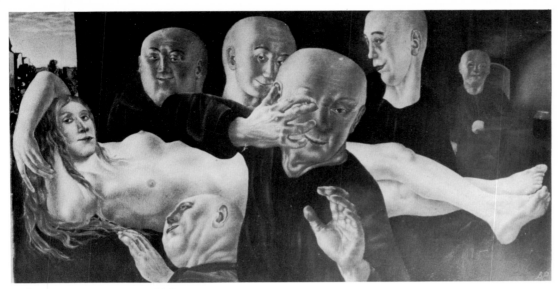

30. Vladimir Rokhlin. *Susannah and the Elders.*

in the extreme, one that requires a fantastic investment of time in each painting. The general concept behind the composition is compatible with surrealism — a fanatic accumulation of detail and filling of space, which builds up to a state of heightened sensory awareness. At the same time Tiulpanov's repeated quotations from past art (including an image of Christ on the cross with a weeping angel) create a pictorial world in which art is more real and more vital than everyday "reality." Obviously, too, Tiulpanov's attention to past art constitutes an unconcealed criticism of the often slovenly technical standards of official art.

It is worthwhile exploring the imagery of Tiulpanov's painting in detail since it reveals a sensibility shared by other unofficial artists. There are spatial dislocations (particularly in the shifting background); there is a love of intricacy for its own sake (the many small objects and painstaking detail, the labyrinthine set of drawers, the intricate Japanese teapot); there are convoluted vegetal forms and transparent bubbles (the latter certainly based on the painting of Hieronymus Bosch). These vegetal forms carry with them, in many cases, pronounced sexual overtones; and they undergo strange metamorphoses, culminating for example in eyes suspended in transparent membranes. The apple in the foreground proves to be worm-eaten; we are viewing not a healthy piece of fruit but an object already in the process of decay. (The "Vanitas" theme — all things must pass — was hinted at in many Dutch still lifes as well.) [4] Even the image of Christ is subject to decay; we see not the living body of Christ but a painted figure whose surface appears to be pitted with holes. Indeed Tiulpanov's own painting, if we examine the right hand section (fig. 29), itself appears to be involved in this process of disintegration. Among Western European surrealists it is probably Salvador Dali who offers the closest parallel to this fascination with decay and morbidity.

Another artist who has turned an attentive eye to past art is Ilya Murin. Murin works mostly in the form of large black and white drawings or etchings. His drawings are executed with a fine pen, with careful modulation of contour lines and shading. Although the historical roots of Murin's style are not as clear as they are in the case of Rokhlin or Tiulpanov, Murin insists on the importance of constantly training his eye on old master engravings. However, like most other unofficial artists Murin claims to be interested not so much in technique as in content. He shares the frequently voiced objection to the lack of content in current Western art, both abstract and figurative. Murin is tolerantly amused by illustrations of US photo-realists and would prefer to see one of Jasper Johns' Ballantine cans convulsively twisted. [5]

Murin's prints from 1975 and 1976 are somewhat on the order of Magritte's fantastic combinations of objects. On a table top against a cloud-filled sky three objects meet, each taken out of normal context — a butterfly, a spider, and a can. In a more recent print the objects he combines are a chicken, a nutcracker, and a mirror (fig. 32). In the same print the half-length female nude and the grinning male head introduce an erotic note which appears in many of Murin's works. Typically the situation is one of desire or anticipation rather than action; the male head here is disembodied, the female figure cool and remote with shadowed face.

## Surrealist Metamorphosis

Several other artists who share some of the preoccupations of surrealism are Petr Belenok, Oleg Tselkov, and Vladimir Yankilevsky. Belenok's theme is endless space in which figures gesture, float, or lock themselves into formations (figs. 70 and 71). The figures are sometimes collage, sometimes painted in a style which approximates popular Soviet images of healthy and positive youth. By subtle changes of context

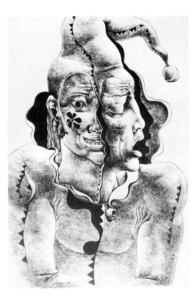

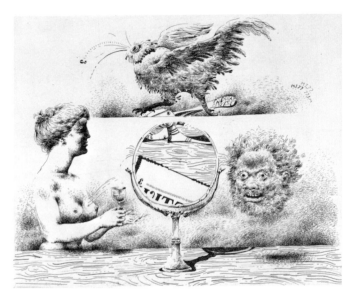

31. Ilya Murin. Untitled, 1974. Ink drawing, 61 x 44 cm.

32. Ilya Murin. Untitled, 1977. Etching, 34.5 x 40 cm.

and scale these figures produce a mood entirely alien to any accepted image of Soviet reality—barren and disorienting, the figures floating in a kind of science fiction space.

Oleg Tselkov is known for canvases filled with grotesquely large, round, smooth heads with staring eyes. He multiplies these heads in a series of canvases, bathes them in iridescent hues, inflates them and crowds them together until they lose their human features. In some cases, the entire body undergoes a strange evolution, as in the etchings of the *Double Portrait* series (fig. 123). In contrast, he may alter the meaning of a head by combination with another kind of object. Tselkov's *Head with Butterfly* (1976) shows a cubist influence in style, yet the underlying emotional content—the transformation of the familiar (a head, a butterfly) into something unfamiliar—conforms to a surrealist sensibility. A more austere treatment of the head is shown in the large paired canvases, both entitled *Falling Mask* (fig. 64). The *trompe l'oeil* nails suspending the panels also pierce their rims and even seem to threaten to puncture the faces.

Yankilevsky deserves comparison not so much with surrealism as with the more recent Chicago "Monster" school. The imagery of Yankilevsky's *City Masks* and his *Anatomy of the Senses* is grotesque and sometimes scatological (figs. 128, 130 and 131). However, certain of his works do bring to mind surrealist parallels; for example, one in which the features of a head become dispersed through a landscape or another in which two female torsos acquire facial features—an inversion perhaps of Magritte's *The Rape* in which a woman's face acquires the features of a torso.[6]

Surrealism in Western Europe was not a strictly defined movement. Adherents worked in a variety of styles ranging from abstract to minutely illusionistic, from monochrome to strident color. Surrealist spokesmen were always generous in welcoming new personalities. They felt surrealism to be something inherent in the human imagination, capable of making its appearance at any time and any place. The basic

surrealist tenet was that the world of the imagination is as real as, or perhaps more real than, the world of everyday phenomena—"bourgeois reality" as they frequently termed it. While clearly some direct influences from the West have been felt in the Soviet Union—for example, the art of Dali or Magritte—there is also simply a shared ancestry, a looking back to the long-standing tradition of grotesque and fantastic art—to Bosch, for example. In addition Russian literature has clearly nourished a current of the grotesque and fantastic, which makes its appearance most strikingly in a work like Mikhail Shemyakin's *Svidrigailov's Dreams* (1966).

Some of the major themes of surrealist painting are those that have made their appearance in the course of this article—the grotesque, the erotic, the magical qualities of familiar objects in unfamiliar combinations. It hardly needs to be stated that these are not the themes of official Soviet art. Soviet art critics have launched periodic attacks on the "deformation of reality" by the surrealists; one by the well-known art historian Igor Grabar was published in 1970.[7] This same charge of deformation of reality is, of course, often leveled at current unofficial art. Ironically this deformation of reality produces an art that is in a sense the inverse of the official "positive" reality; the preoccupation with content is shared by both groups. In keeping with this preoccupation, one finds that even where abstract art is concerned, the most favored of styles among unofficial artists has been the pathos-filled abstract expressionism of Vladimir Nemukhin or Ernst Neizvestny.

What is clearly significant is that surrealism arose in Western Europe during a period of widespread disillusionment with the public sphere of life. During the twenties and thirties European art was grouped into two camps, surrealism versus constructivism. The latter was confidently political and utopian; surrealism was by contrast individualistic, highly pessimistic about the possibility of political or social progress, and emphasized the irrational in its concept of

the human personality. While there are signs of a renewed interest in constructivism among unofficial Soviet artists, it is certainly surrealism which has been dominant during the past two decades.

**Notes**

[1] For further discussion of these artists and for illustrations of works not in the present exhibition, see Igor Golomshtok and Alexander Glezer, *Unofficial Art from the Soviet Union* (London 1977); Mihail Chemiakine and Alexandre Glezer, *La peinture russe contemporaine,* Palais des Congrès (Paris, 1976).

[2] Ilya Murin, for example, like many others, would prefer not to be associated with *any* group or movement, including ''unofficial art.''

[3] Otari Kandaurov, ''Metarealism: Creative Method and Creative Credo (Theses),'' in Golomshtok and Glezer, *Unofficial Art,* p. 147.

[4] According to the artist's own statement, the painting is based on the idea of the mystical philosopher Florensky that the good is the only genuine reality, a notion which Tiulpanov extends to the subconscious world as well. The composition expresses the weighing of Good and Evil, while the complex details are related to the mysterious interpenetration of objects and perceptions in our conscious and subconscious states, in dreams and as if after death.

[5] In all probability, the extravagantly twisted cans which appear in Murin's prints of 1975-76 are an ''answer'' to Johns.

[6] Yankilevsky's transformations of the human figure are also reminiscent of the drawings of André Masson; for example, *Hatchings and Germinations,* 1938, published as part of Masson's *Anatomy of My Universe.*

[7] See also the detailed and well-illustrated book by I.S. Kulikova, *Siurrealizm v iskusstve* (Moscow, 1970).

# 5 Nonobjective Art: The Container Is the Thing Contained [1]

Sarah P. Burke

There are talented and dedicated artists creating nonobjective art within the Soviet Union, but their number is small. Within unofficial art it is not the dominant style, taking second or third place to surrealistic and representational canvases. The fact is that the Soviet Union is not fertile ground for nonobjective art, and the reasons for this are both philosophical and practical.

By long tradition Russian art has had a literary or philosophical quality. If it has not been directly message oriented, then it has had strong theoretical underpinnings (e.g., Malevich). The concept of art as an optical experience, as an entity in itself divorced from its sociological environment, is not a natural one to the Russian experience, and is even less natural to the Soviet experience. In the early thirties, Soviet artistic policy makers institutionalized the literary function of art in the form of socialist realism, emphasizing art's usefulness to society and insisting that the realistic style was most appropriate to this relationship. Of course, all unofficial art is to some degree at odds with the official policy, but nonobjective or abstract art, as an optical experience divorced from its sociological environment, stands in direct opposition to the very tenets of Soviet artistic policy. By decree, therefore, this art has received the distinction of being at one and the same time the most, and the least, politically engaged art form and consequently has been receiving the brunt of the criticism which has been leveled at unofficial art as a whole. [2] Little has changed since the 1960s when Khrushchev attacked Ehrenburg for his defense of modern art, concluding that Ehrenburg defended it in order to support the opportunity for the existence of such phenomena in the USSR. "This would mean recognition of coexistence between socialist realism and formalism. Comrade Ehrenburg is making a gross ideological mistake, and it is our duty to help him to realize this." [3]

Today the attacks are slightly more refined, but the premises are the same. A review of the Leningrad exhibition of September, 1975, by a member of the artists' union, conceded that there were some talented works at the exhibition but attacked the nonobjective works in particular, calling them amateurish, pretentious, outmoded, antiartistic (read: antirealistic), and finally antihumanistic. The reviewer's statement that "everything antiartistic is also antihumanistic" sums up the government's uncompromising position toward the nonobjective artist. [4]

While the government's attitude toward these artists is clearly hostile, there is, moreover, little acceptance for their works among the Russian public or even among other unofficial artists. In an essay on Soviet unofficial art, the critic Golomstock notes the small number of abstract artists and suggests that although the younger Muscovite and Leningrad intelligentsia took a greedy interest in the American abstract artists, they were:

> . . . nonplussed by their own abstract artists because they could not find in them what it was they had sought . . . in "fantastic realism," namely a direct link between the deep social and spiritual developments of the time and their interpretation through art. [5]

Golomstock continues that "many artists who began with Classical Abstraction somehow went through that stage very quickly and either returned to a figurative style . . . or turned to the ideas of Pop Art or Conceptualism . . . " [6] In other words, abstract art was not the most natural medium to fulfill the literary function which has been so much a part of Russian and later Soviet art.

These are the main philosophical handicaps under which the nonobjective artist works; but there are practical ones as well, and they concern the lack of materials, small studio size, and limited exhibition space. These handicaps are not unique to the nonobjective artists and have to be dealt with by all artists in the Soviet Union, but the consequences for the nonobjective artists are greater than for the others. Most importantly they have not been able to investigate new systems and new materials to the extent that their counterparts in the West have done. For instance, canvas size has remained small for reasons not necessarily aesthetic (studio size, exhibition space, storage problems); therefore, Soviet artists have not been able to scale their art monumentally as their counterparts in the West have done. It is a fact that many of them would welcome the opportunity to do so. Furthermore, the predominant media of these artists are oil, watercolor, and gouache, for they are most readily available. The range and quality of synthetic colors—not to speak of other materials—used in the West are not available in the Soviet Union. The list of handicaps could go on. Suffice it to say that the environment in which the nonobjective artists work is a difficult one both practically and philosophically.

## Abstract Expressionism

Given this unpromising environment, who are the artists who paint nonobjective works? They cannot be characterized easily, as they paint in widely varying styles; but certain tendencies are apparent. There are many artists, mainly from Moscow, whose canvases reflect a contact with American abstract expressionism and its later blending with pop art. These painters were all indebted artistically to the influx of exhibitions of Western art which occurred in the Soviet Union in the late fifties and early sixties. Of particular importance were the *International Exhibition* at the *1957 World Festival of Youth and Students* in Moscow and the *1963 Exhibition of American Graphics* where Russian artists saw the works of such American artists as Johns, Rauschenberg, Rosenquist, and Dine for the first time. The forcefulness and directness of the American style must have appealed to many Soviet artists. The action painters, especially, caught their imagination. Many who were immediately taken by that aspect of abstract expressionism experimented with it and then moved to more representational works. They seemed to assimilate the expressionist technique while finding the abstract side less satisfying. Such artists were

33. Vladimir Yakovlev. Untitled, 1962.
Watercolor, 40 x 27 cm.

34. Lev Kropivnitsky. *Outer Galactic Logic*, 1960.
Oil on canvas, 68.5 x 44 cm.

35. Lydia Masterkova. Untitled, 1971.
Gouache, 68 x 51 cm.

Nemukhin, Yakovlev (fig. 33), Lev Kropivnitsky (fig. 34), Yankilevsky, and Zverev. Today these artists work in various styles, but the similarities among their works from the sixties are striking. All exhibit the loose, rapid handling; the uneven densities of paint; the brush, finger, or rag marks that are characteristic of abstract expressionism. Zverev, in fact, still uses the action painting style for his representational paintings (figs. 134 and 135), and the backgrounds for Kropivnitsky's pop compositions are painterly and clearly abstract expressionist. The American exhibition also touched artists who considered themselves representational from the beginning. For example, Ely Bielutin's robust paintings (fig. 49) and monotypes are striking for their forceful strokes, and in their feeling of spontaneity are reminiscent of De Kooning and Gottlieb.

In addition to the above artists, there were those who assimilated and kept both the abstract and expressionist sides of abstract expressionism. Outstanding among these are Lydia Masterkova and Evgeny Rukhin, whose highly structured and textured abstract canvases show contact with painters such as Johns and Rauschenberg and awareness of a major tendency in the sixties in the United States: the creation of permuted sets where the structure stays the same while the palette changes. Masterkova is a master of composition. She began painting abstract works in 1957, gradually moving from traditional expressionist ones to a more structured personal style which recently has included an extended series with numbers. In this series the combination of numbers (0, 1, 9) and circles has astrological significance, the former representing extreme astral conditions (fig. 92). Masterkova works chiefly in oil, combining a painterly style with attachments to the canvas surface, but also does lithographs and etchings (fig. 35). Her palette is severe and consists almost exclusively of blacks, greys, browns, modulations of violet and blue and white (for the backgrounds). On to the freely brushed or dripped white background, doilies, lace, corrugated cardboard, or other materials are pasted. Her canvases are often divided horizontally into thirds with a group made up of the pasted material on one third and other material on another. The attached materials are transformed on the surface of the canvas — in one series to numbers — so that they lose their previous associations and are often recognizable only under close scrutiny. Masterkova's works are powerful in their starkness, which results in part from the application of strongly textured dark earth colors which reach down the upper third or half of the canvas and contrast sharply with the stark white background.

Evgeny Rukhin's nonobjective works have a quality different from Masterkova's although the artists share an interest in texture and attachments to the canvas (figs. 115, 116 and 117). He began painting in 1963, and experimented with various styles and canvas shapes before moving to heavily textured abstract works. Rukhin gives almost all of his attention to the surface of a painting, and a single work is made up of many layers of paint. He uses a synthetic white paint for most of his works, and as he applies it in layers he is constantly aware of the relationships among the various relief levels. During this process he attaches found objects; for example, fragments of furniture, paint brushes, combs, fabric. The objects are sometimes humorous (a paint tube caught in a mouse trap [fig. 36]), and give an ironic quality to the work. His use and placement of these objects, often directly in the center of the canvas, are reminiscent of the paintings of Jasper Johns, whom Rukhin greatly admired. Another characteristic of Rukhin's paintings is the use of stencils; most often re-creations of announcements found in apartment building entrances or other areas of Soviet reality. Both the stencils and the attached objects interact with the canvas surface in a complex way to force everything to the front plane so that the viewer looks at the work rather than into it.

37. Edward Shteinberg. *Composition,* 1977. Oil on canvas, 50 x 60 cm.

36. Evgeny Rukhin. Untitled, 1976. Oil on canvas, 73 x 71 cm.

38. William Brui. *No. VI,* 1967. Etching, 45 x 44 cm.

Masterkova's and Rukhin's canvases are highly structured and relate more directly to later abstract expressionism (Johns) than to its earlier period (Pollock, Gottlieb). As was already noted, many artists who tried action painting abandoned it for other forms. Some artists, however, did not abandon it. Prominent among these is Yakov Vinkovetsky whose works are reminiscent of those of Pollock. His abstract paintings consist of swirls and drips of oil paint applied one on top of the other apparently spontaneously (fig. 124). Interestingly enough, Vinkovetsky also does figurative paintings which have strong religious themes. The abstract canvases of Boris Zeldin should be mentioned at this point, although they are less spontaneous than Vinkovetsky's. They are curious works and vary widely. Some are made up of short brushstrokes and others of freer lines (fig. 132).

### The Russian Abstract Tradition

While the above artists owe their primary inspiration to American art, a second group of nonobjective painters looks back to and continues the Russian abstract tradition of the 1920s. It is true that virtually all of the unofficial artists acknowledge their debt to this Russian tradition, but these artists acknowledge it more openly and formally. The members of the Moscow kinetic group "Movement" and of the Leningrad Sterligov Collective, discussed earlier in this book, are most representative of this trend. Besides these groups there are two noteworthy independent artists, one from Moscow and the other from Leningrad.

The Moscow artist, Edward Shteinberg, shows an admiration for the works of Malevich and El Lissitzky. His works are nonetheless quite distinct and original in style. Like his predecessors, Shteinberg uses geometric forms. The interesting feature of his work, however, is the palette of opaque pastels and shades of white. The latter are used to create barely perceptible divisions on the surface of the canvas, the

pastels being used for the geometric forms. In one work, which is strikingly similar in form to one of Lissitzky's, geometrical shapes float on the surface and only slightly recede into it (fig. 6). Shteinberg achieves this effect, which is quite opposite to Lissitzky's, by using pastel colors of almost equal value. His other works are equally subtle, and there is a gentleness about them which may result from their religious-metaphysical inspiration.

In Leningrad William Brui was one of the first to paint completely abstractly. Like Shteinberg, his works impart a coherent feeling; and like Shteinberg, he admires and studies the Russian suprematists and constructivists. Geometrical forms dominate his early works (figs. 75 and 76). In these he shows himself to be skilled at creating illusions of depth, but they are most interesting for their investigation into the play of light on the geometrical forms: light which appears at times to come from without and at times from within. An interesting early work is a book composed with the poet Grabov entitled *Ex Adverso* (1969), executed in nine copies. The book can be read and viewed forwards or backwards and, taken as a whole, is an affirmation of the nondidactic nature of art. Since his emigration in 1970, Brui has been continuing his formal investigations in larger canvases, in which a myriad of black lines crisscross the monotone surface, becoming denser at the sides and thus creating lighter glowing areas toward the center. There is a compelling quality in the simplicity of these canvases that draws the viewer to them and into them.

### Other Tendencies

A third group of nonobjective artists has emerged at the exhibitions of unofficial art held in 1975 in Leningrad and Moscow and in the spring of 1977 in Leningrad. These artists are interested in the flatness of the canvas surface rather than its texture, its depth, or the play of light upon it.

They seem to be following the lead of the American artists of the sixties who tried to eliminate evidences of personality which had been associated with earlier abstract art. Their works are characterized by broad flat areas of color and have an intellectual quality. The Leningrad artist Leonid Borisov, for instance, creates highly rational canvases and sculptures which evolved through pop art to his present nonobjective style (fig. 74). He mocks traditional easel paintings with his whimsical metal attachments atop flat color, quite different from the attachments in the works of Masterkova and Rukhin, which merge with the canvas surface. The works he exhibited at the September, 1975 Leningrad exhibition evoked the cry from one critic that "L. Borisov had some you could have turned upside down." [7] Whether or not these works mark the beginning of a new trend in Soviet nonobjective painting remains to be seen.

There are other nonobjective artists whose works are eclectic. The subtle gouaches and oils of the Leningrad artist Evgeny Mikhnov-Voitenko (cover and fig. 55) are unique. Until recently his works were seldom seen outside his apartment and were, consequently, known to only a few persons. His paintings have a haunting quality about them, a delicate beauty, which sets them apart from the other nonobjective works. Mikhnov-Voitenko works primarily in gouache, using pale transparent washes and negative light areas and accents to create a myriad of organic shapes across the canvas surface. His works convey a feeling of movement and fluidity, and some of their configurations are reminiscent of a child's finger paintings. At the same time there is an underlying order which results from the imposition of detailed shapes onto the pale, merging color washes. What results is what the critic Dragomoshchenko has characterized as a mechanical ballet.

Another artist whose works are difficult to characterize is the Leningrader Yuri Dyshlenko. One of his most interesting works is a series of five canvases which together are a statement about the artistic process (fig. 50). Vaguely representational forms begin to disintegrate and gradually merge with other abstract forms until by the last canvas they have been completely swallowed up by them. Dyshlenko's paintings are interesting for their play on the spectator's perception and for their lack of firm structure, a quality not characteristic of the majority of the nonobjective artists.

It is certain that there are many more nonobjective artists who have not yet been discovered. It is clear, moreover, that nonobjective art is alive among the unofficial Soviet artists. In spite of the difficult environment in which it is created, it will continue to articulate the relationship between art and reality within the work of art itself and will not let its public forget that the work of art has an artistic reality of its own — that the container is the thing contained.

## Notes

[1] "The Container Is the Thing Contained" is the title of an unpublished lecture on American literature of the seventies, which was read in spring, 1977, by John Brantley, Professor of English, Trinity University.

[2] Two titles should suffice to illustrate this point. The first is a monograph entitled *On the Arguments about Abstractionism in Art*. A. Lebedev, *K sporam ob abstraksionizme v iskusstve* (Moscow, 1970), which contains chapter headings such as "Abstractionism — enemy of life, humanity and beauty" or "Abstractionism — the product of the disintegration of bourgeois culture." The second, "False Values of Abstractionism," appeared in the Soviet journal *Ogonek*. D. Nalbandyan, "Falshivye tsennosti abstraktsionizma," *Ogonek,* No. 32 (August, 1975).

[3] Priscilla Johnson and Leopold Labedz, eds. *Khrushchev and the Arts* (Cambridge, 1965), pp. 169-170.

[4] V. Zvontsov, "Esli tebe khudozhnik imia," *Leningradskaia Pravda* (October 16, 1975), p. 3.

[5] Igor Golomshtok and Alexander Glezer, *Unofficial Art from the Soviet Union* (London, 1977), p. 100.

[6] *Ibid.,* p. 100.

[7] Zvontsov, "Esli tebe khudozhnik imia," p. 3.

# 6 Conceptual and Pop Art

Norton Dodge

There is always a lag in our perception of what is happening in the Soviet art world. For example, a comprehensive American study of kinetic sculpture published in 1969[1] did not mention the extensive work in kinetic art being done in Moscow during the 1960s. But specialists in Soviet art, such as Michel Ragon[2] and John Bowlt (see Chapter One), have provided information about developments in this field; and Lev Nusberg, organizer of the *Dvizhenie* (Movement) group of kinetic artists, is now accessible in Paris.

Our awareness of recent developments in Soviet pop and conceptual art has also lagged. The work of some of the early conceptual artists—Yankilevsky, Kabakov, and Pivovarov, members of the Sretensky Boulevard group—is on rigid fiberboard and of such a massive scale that it can only be seen in the artists' studios. This is also true of many of the examples of the newer pop and conceptual art of other artists. To date, no leading figure in pop or conceptual art has emigrated to the West bringing his works or his knowledge with him.

In an attempt to broaden Western awareness, while conveying the flavor of this newer art as it has evolved in recent years in Moscow, we focus on only a half dozen of the better known and most accomplished artists even though many more would deserve attention. Among these lesser known artists are Alekseev Driuzhin, Dubach, Illyakov, Monastersky, and the trio of young conceptual artists, Donskoi, Roshal, and Skersis (fig. 45).

## Yankilevsky

Vladimir Yankilevsky does not fit neatly into any past or present classification of art in the Soviet Union or elsewhere. Although he would deny that his work belongs to either surrealist or conceptual art, it contains elements of both (see Chapter Four). If his work reflects the influence of his teacher Ely Bielutin and his close friends Ulo Sooster and Ernst Neizvestny, it is above all very much his own and is readily recognizable as such.

Yankilevsky studied at the Academy of Design and the Polygraphic Institute in Moscow, where Ely Bielutin helped free his artistic sensibilities and develop his unusual talents. In 1961 he completed his first large triptych, which became a model for his basic form. In the following year, when Bielutin and a group of his pioneering students were invited to participate, along with the sculptor Neizvestny, in the ill-fated Manege exhibition of 1962, Yankilevsky and Sooster were also invited to take part. Like the other nonconformists in the exhibition, Yankilevsky received his share of Khrushchev's umbrage.

After 1962, he continued to work productively and soon completed his second and third massive bas-relief triptychs, forerunners of many others. Typically these are about four feet high, fifteen feet long, and six inches deep. In these large triptychs, one end represents a male figure and the other a female. Between these cybernetic-age idols is an elongated central panel which connects the two in a complex composition. The colors are often luminescent and

unnatural. The effect is disquieting because of the combination of the primitive and biological with ultramodern cybernetic imagery. As Jane Nicholson has pointed out, these figures seem to exist ambiguously, half-way between the biological and mechanical worlds.[3]

The grotesque and ambiguous is a powerful element in Yankilevsky's graphics, many of which form series developing a particular theme, which may be developed further in the large triptychs. His extensive album *Mutants* (fig. 39) presents a variety of grotesques, sometimes imperfectly concealed behind conventional disguises. These humanoid creatures, inhabiting a barren, cosmic landscape, may consist solely of a leg and an arm—the arm carrying the ubiquitous Soviet briefcase—or may have a head blowing a trumpet where a tail should be. Despite the macabre quality of these creatures, the viewer is led to identify and sympathize with them. These are not casualties of some postnuclear age but products of our own society. Indeed, we are the mutants, the psychic cripples suffering from the aberrations and distortions which Yankilevsky has expressed in artistic terms.

It is Yankilevsky's concern for man as "a kind of cosmic being in the universe: not on the level of science fiction but on the level of prime causes and effects of existence"[4] which gives his work special interest and value (figs. 128 and 129). Like the powerful and disturbing work of Velickovic, a Yugoslav surrealist now in Paris, Yankilevsky's work, no matter how bizarre, reflects the utter sanity and deep insight with which he creates his special world of horrors, torments, and delights.

## Kabakov

Another conceptual artist and a close friend of Yankilevsky is Ilya Kabakov. Born in 1933 in Dnepropetrovsk, he completed his art training at the Surikov School of Fine Arts in Moscow in 1957. Since then he has pursued a very successful career as an illustrator of children's books, but his best creative efforts have been devoted to works done essentially for himself and his friends in the Sretensky Boulevard group.[5] They reflect his contemplative intellect as well as his playful sense of the absurd. Among them are large (7 x 16 feet) works on fiberboard which consist primarily of empty areas enameled in pastel or white, with a small section or corner devoted to a scene or object. In some works, the space may be filled with a series of words or statements evoking some philosophical question or concept.

His smaller pictures use everyday products of a nonaesthetic nature as a starting point. He explains: "A label is not a work of art, but a label perceived in the context of a classical picture has the potential for gigantic dramatic collisions." He continues his explanation with these comments:

Any picture consists of fiction and real essence. With some artists, the covered surface of the whole picture is the sum total of what it depicts; with others, the real essence lies at the center of the picture or perhaps at one

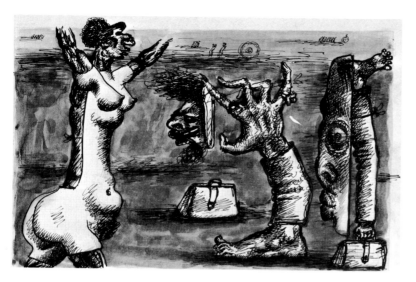

39. Vladimir Yankilevsky. Untitled, 1971. Drawing, 21.5 x 32 cm.

40. Viktor Pivovarov. From the cycle *Garden*, 1976. Gouache and ink, 14 x 20 cm.

of its edges. Consequently, all the remainder is fiction. In my case everything depicted in my pictures is fictitious. The meaning, however, does not disappear, but remains all the time behind and beyond the painted surface. One simply has to know how to discern it.[6]

Kabakov's albums are, in effect, picture books for adults. Over the years he has created almost a dozen of these albums of twenty to forty oversized pages, each expressing a comment on the human condition in some simple story form, or by the sequence of pictures alone. Many of these adult, children's books—this seems the best way to refer to them—strike a universal human chord even though the illustrations root the story firmly in Russian or Soviet surroundings. *A Picture Dictionary* uses the simple outline drawings of a child's alphabet book to depict, with unpretentious elegance, the objects of everyday life—tea cup, glass, table, chair. Each object is labeled in careful Russian script. Kabakov has in a strange sense magnified and ennobled these objects, reminding us how important they are in Soviet daily life. Each viewer will have his own interpretation of these pictures, but it would seem that, like Magritte in his painting of a pipe labeled *Ceci n'est pas une pipe,* Kabakov is raising the question of the nature of reality and the nature of art in a refreshingly unpretentious way.

Another album is about a man in a shower (fig. 80). The man stands unchanged in a sequence of forty pages. What changes sheet by sheet is the water flowing from the shower. On the first sheets we see a huge, threatening drop forming and then enveloping the head and shoulders of the man. In the next pages, his body is completely enclosed by the water like a shroud. Next, although he remains unmoving, we see him being freed of the water through an exertion of will. The water does not slide down to form a puddle at his feet as one would expect, but is raised and repelled from the body in all directions until it finally disappears and the man, impassive and unchanged, stands free. The album closes

with a recapitulation, like transparent overlays on a single page, of the man being engulfed and, on a second page, of the process of his being freed. Here we have a parable which Kabakov has invited each of us to consider and respond to in our own way. As his close friend, the illustrator and painter Pivovarov has aptly remarked, ''Kabakov is one of those artists whom most people can't understand, but who everyone knows has genius.''[7]

### Pivovarov

Viktor Pivovarov, also an illustrator of children's books, is younger than Kabakov and readily admits his debt to Kabakov's work. He also paints with enamel on fiberboard. Like Kabakov's, his series of large conceptual works, as well as his smaller graphics and watercolor albums, raise philosophical questions regarding the interaction of man and his world. Pivovarov depicts the problems of ''Everyman,'' whose world, according to one observer of the Soviet cultural scene, ''is a combination of inhibiting interiors, vast blank spaces and tiny glimpses of distant horizons, like little windows on a bigger world beyond.''[8]

In his graphics of the late sixties, Pivovarov worked with engineering structures as well as biological forms. Later, moving closer to surrealism, he introduced the omnipresent figure of ''Everyman'' and began employing unexpected shifts in perspective in *Lost between Woman and Constructions, The Face,* and other works. In a 1973 series his work became less geometric and more figurative, relying for effect on unexpected juxtapositions of objects.

A recent whimsical return to some of the motifs from his previous work is the eleven-part watercolor series *Stairway of the Spheres* (fig. 103). Here we see the characteristic landscapes, interiors, and the ever-present ''Everyman'' encapsulated in spheres or billiard balls, bouncing down a stairlike slope. The unexpected happens when this man,

41. Komar and Melamid. *Super Object—OLO.* A language ornament. Your every word is gold, your every word—a pearl!

42. Komar and Melamid. *Super Object—SMALL DUNGAN.* The center of spiritual life: Replace the traditional center of your home—the dinner table—with its analogue.

43. Komar and Melamid. *Super Object—CHAROG-15,* Protect the purity of your thoughts.

whose head and shoulders alone are visible, makes quarter-turns within his sphere in successive pictures, and balls fuse or come apart, leaving the decapsulated man with his back to the viewer to sail upward into space and perhaps to disappear.

Part of a more restful cycle called *The Garden* (fig. 40) develops the theme ''Where am I?'' The question itself is philosophical. What the answer is and how meaningful or profound it is depends, of course, on each viewer's attitude and capacity. The whole exercise is done with delightful simplicity and a light touch of irony.

Following the example of Kabakov, Pivovarov characteristically uses prosaic objects for commentary on life. A perfect illustration is the small, skillfully drafted watercolor (fig. 102) which provides, like Kabakov's picture dictionary album, the names and pictures of sixteen everyday objects, an apple, a spoon, a button, and so on. The artist, having drawn these objects, asks, ''But how can one depict the life of the soul?''

Like Kabakov, Pivovarov tries to establish a dialogue between himself and the viewer. The two may not have met before, but with the link of common experience, they will communicate at once because ''it is a dialogue they have conducted before, albeit separately.''[9]

### Komar and Melamid

In the winter of 1976, with a crowded opening at Ronald Feldman's Gallery, the works of Moscow artists Vitaly Komar and Aleksandr Melamid appeared upon the New York art scene as a complete surprise, even to New Yorkers familiar with Soviet unofficial art. Few were aware of how rapidly new talents had emerged in Russia in recent years.

Komar and Melamid, both in their early thirties, seemed instinctively to speak the language of the New York art world while their art remained centered in their Moscow ex-

perience. Just as Warhol made art of soup cans and pop culture celebrities, Komar and Melamid employed the pervasive political clichés of Soviet life as a point of departure. As John Leonard noted in his *New York Times* review, ''They are 'realistic' about Soviet mass culture the way Andy Warhol is 'realistic' about American pop culture.''[10] Operating in a realm between pop and conceptual art, they rewrote slogans, parodied political posters, and depicted themselves in the traditional double portrait poster format previously reserved for Lenin and Stalin. They gave further novel twists to old clichés by painting Marx on a checked dishrag as a beardless, bespectacled teenager—a startling way of depicting the Soviet ''father figure'' (fig. 5). Their biting wit came full circle to satirize Warhol himself in a series of American soup cans, less pristine than in Warhol's prints, but dignified and enhanced by instant aging with a blowtorch.

Komar and Melamid returned to spoof the consumer culture in their second show in New York in May of 1977. Taking the posture of deploring the disappearance of class distinctions, they explained that, ''By trying to be like everyone else, the ruling class has obliterated the elite class and the intellectual divide between it and the masses.'' They argued that class distinctions must be created anew, and to this end they offered thirty-six *Superobjects* (figs. 41, 42 and 43). Their catalogue included such tempting items as the ALTON, a pedestal of precious wood, used ''to vaunt your superiority over anyone or anything.'' It is claimed to be ''the ultimate in self-assertion.'' Others might prefer the OLO, a jewel of pearl and gold worn in the mouth to assure that ''your every word is gold, your every word—a pearl!'' Failing all else, one might purchase the SMALL STERDAK, an elegant stand made of eucalyptus wood which provides ''the ideal support for a depressed spirit.''

Komar and Melamid's work always shows a fertile and wildly imaginative creativity, but in addition to this creative

45. Donskoı, Roshal, and Skersis sowing the field.

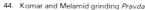

44. Komar and Melamid grinding *Pravda*

whimsy there is invariably insight and substance. For example, they have invented a realist artist, N. Bukhumov, and painted on his behalf a series of sixty-four works covering the cataclysmic sixteen-year period of Soviet history from the Civil War to the Great Purge. Through all these fateful years, Bukhumov paints the same landscape, which changes only with the seasons. However, his nose appears on the left of each canvas, growing larger with age. Its presence obeys an obstinate logic since Komar and Melamid decided that Bukhumov lost his left eye in a dispute at art school with an avant-garde constructivist and, as a true realist, must include the nose which intrudes from the left into his field of vision.

A fascinating biography of a Russian "Everyman" is another major work. It unfolds, panel by panel, in 197 miniature paintings an inch and three-quarters square. These minute panels depict the major events of the hero's life — his birth; his childhood adventures; his discovery of girls; and tragedies such as the arrest of his father, the death of his lover from a late abortion; his subsequent despair; and finally his search for his true self. These tiny pictures are executed in a variety of styles, each appropriate to its subject — Gauguin's style for sexual scenes, a surrealist style for birth, pastoral styles for the countryside, and so forth.

An especially ironic work is one which seems to be abstract, but actually depicts in code, by means of a series of multicolored squares, Article Twenty-Nine of the Russian Constitution which guarantees freedom of speech. Another conceptual work on the theme of freedom of the press is the documented reduction of a paint-stained copy of *Pravda* (Truth), the Communist party's official organ, to a hamburger-shaped patty: the artists force it through a meat grinder (fig. 44). Another whimsically serious work is a large painting entitled *Plan for a Blue-Smoke Producing Factory* (fig. 52). In romantic style it shows an industrial plant looking like a Greek temple belching forth beautiful, clear air into an atmosphere grey with smog.

One of the most interesting works seen at the New York exhibition is an outgrowth of Komar and Melamid's desire to emigrate. When they requested emigration papers some months ago, each lost his job, and they still do not know when or whether they will be able to leave. In response to this situation they have created a country of their own, Trans-State. They have written its constitution, issued passports to themselves, and printed money.

Some of the main features of Trans-State are explained by Grace Glueck: "Dedicated to the proposition that all men are created individuals, the new nation has as its ironical rallying cry the imperial 'L'estat, c'est moi' of Louis XIV. Trans-State . . . celebrates independence and autonomy of the personality from the infringement of the Powers of Darkness." [11] As the Constitution provides, membership is open to any person on earth "who in his own opinion falls outside the structure of the functioning state systems . . . and does not agree with the degradation of his 'I' to an empty sound in space and a naked letter on paper." [12] One of Trans-State's most intriguing features is that each member becomes a citizen-state himself and is addressed not as "Comrade" or "Mr." but as "State" — for example, "State Komar" or "State Melamid." Whether international organizations, such as the United Nations, or individual states will recognize Trans-State is not yet known.

While Trans-State has its entertaining aspects, the involvement of its two young creators in the concept has its deadly serious overtones in view of the delay in their receiving permission to leave the USSR. Their own comments, as reported from Moscow by David Shipler, can best convey something of the basic philosophy and continuing energy of Komar and Melamid as they wait for their release:

"We are not artists," says Aleksandr Melamid.

"We're conversationalists," says Vitaly Komar.

46. Rima Gerlovina. Combinational play-poem, *Paradise, Purgatory, Hell,* 1976.

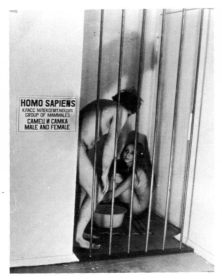

47. Valery and Rima Gerlovin. *Zoo,* March, 1977.

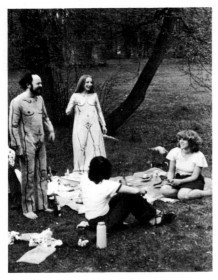

48. Valery and Rima Gerlovin. *Picnic-Happening,* 1977.

"We make every conversation into a concrete thing," explains Mr. Melamid . . .
Mr. Komar observes, "But the technical things are not important. The important things are our conversations."
"We work like a factory," says Mr. Melamid. "It's a mechanical process."
"We want people to start talking after they see our paintings, just as we talk to produce them," Mr. Komar says.[13]

## The Gerlovins

Rima and Valery Gerlovin, another pair of young Moscow artists, have been active in the field of conceptual art for the past four years. Unlike Komar and Melamid, who never work separately, the Gerlovins work separately much of the time but also collaborate as a very effective team.

Valery Gerlovin's interests center on metal sculpture made from parts of erector sets and the construction of exhibit cases in which collections of labeled objects are displayed or in which mini-environments having some philosophical or conceptual significance are created.

Rima Gerlovina's own conceptual work is focused on labeled boxes in the form of cubes—literally hundreds of them—which may open to reveal further information inside. These cubes are metaphors, and a single cube may form a complete work; but often they are combined into larger arrangements which permit complex interactions among them. For example, by using lines of poetry which appear on each face of a set of cubes, new poems can be created by shifting the position of the cubes. One work of sixty cubes, each labeled with the name of a famous person—for example, Plato, Picasso, Catherine II, and Stalin—permits the viewer to consign these personages to sections labeled Paradise, Purgatory, and Hell (fig. 46). In this art the role of the viewer is far from passive; his involvement is direct as he plays an active part in the creative process.

The Gerlovins have also created performances in which they have participated as actors. In the performance *Zoo* which occurred in March, 1977 (fig. 47), they were caged and exhibited in the nude, just as other animals in the zoo, with the label "Homo Sapiens, group of mammals, male and female" on their cage. While the Gerlovins act with the purpose of achieving particular effects in performances, those who observe them can react in many different ways. As with the cubes, it is these reactions, whatever they may be, that are the real purpose of the work.

In another recent work more like a happening than a performance, they attend a picnic with friends, which is reminiscent of Manet's *Dejeuner sur l'Herbe* (fig. 48). Valery is clad in a white suit painted front and back with the outlines of a male nude figure. Rima is clad in a similar dress with the outlines of a female figure. Everyone involved in the picnic seems natural and at ease, but perhaps only after overcoming the initial shock of the Gerlovins' appearance. The purpose of these costumes is to encourage the viewer to examine his concepts of what is natural, what is real, and what is proper.

The Gerlovins have many plans for future projects, and a number of works are already in preparation. Although their artistic styles and methods differ from those of Yankilevsky, Kabakov, and Pivovarov, and to a lesser degree from those of Komar and Melamid, with whom they have a close affinity, the purpose of all these artists is much the same—to invite the viewer to open his mind, to examine his prejudices, to uncover new ideas and concepts, and to reflect upon the ironies of the condition of modern man.

The notion of pop art as it evolved in Britain and America does not fit the circumstances of Soviet life: in fact, its very foreignness adds a special piquancy to many Soviet works or calls for its application with a special twist as in the works of Komar and Melamid. But the relationships of Soviet artists to Western conceptual art is even harder to define.

The two successful exhibitions of the pop and conceptual art of Komar and Melamid in New York suggest that they and other similar Soviet artists have found a language which bridges the gap between the two worlds of art. Their art, though dealing perceptively and sensitively with the human dilemma as seen through their own experience, speaks as well to us in our own circumstances.

### Notes

[1] Jack Burnham, *Beyond Modern Sculpture: The Effects of Science and Technology on the Sculpture of this Century* (New York, 1969).

[2] Michel Ragon, "Le Groupe Cinetique 'Dvijenie,'" *Chroniques de l'Art Vivant,* No. 23 (September, 1971) pp. 17-19. See also *Studio International,* August, 1966; December, 1967.

[3] Jane Nicholson, "La Nouvelle Gauche à Moscou," *Chroniques de l' Art Vivant,* p. 12.

[4] Vladimir Yankilevsky, statement in I. Golomshtok and A. Glezer, *Unofficial Art from the Soviet Union* (London, 1976), p. 163.

[5] In addition to Kabakov, this group includes Yankilevsky, Pivovarov, Shteinberg, and Bulatov.

[6] Ilya Kabakov, statement in Golomshtok and Glezer, *Unofficial Art from the Soviet Union,* p. 146.

[7] Robert Kaiser, "When Quality Is Its Own Reward," *The Washington Post* (December 22, 1974).

[8] *Ibid.*

[9] Kabakov, statement in Golomshtok and Glezer, *Unofficial Art from the Soviet Union,* p. 147.

[10] John Leonard, "Smuggled Soviet Art Is a Witty Variation of Ideology," *The New York Times* (February 10, 1976).

[11] Grace Glueck, "Dissidence as a Way of Art," *The New York Times Magazine* (May 8, 1977). Further detail on Trans-State may be found in this article.

[12] From Komar and Melamid, *Constitution of Trans-State.*

[13] David K. Shipler, "Impish Artists Twit the State," *The New York Times* (February 6, 1977).

# 7 The Future of Soviet Art*

Igor Golomstock

To speak about the future of Soviet art is difficult for someone who cannot divine the destinies of mankind from the works of Marx, Engels, and Lenin (or, until recently, Stalin). To speak about the immediate future means to project a potential development of certain existing conditions, assuming that the other social parameters remain stable. The distant future, in its very nature, is undefinable from the positions and parameters of the present. It is possible to speak about it only on different methodological grounds. The question is: Will the fundamental values of Soviet art, whether of socialist realism alone or of the wider artistic life in the Soviet Union, be preserved as were those of ancient Egypt, classical antiquity, or the Renaissance? In a short article one can offer only the most general sketch of these problems.

In Stalin's time, everything was simple; nobody had any doubts as to the nature of Soviet art, its features and parameters, its heroic past and glittering future. Anyone looking at the works of Gerasimov, Tomsky, and Nalbandyan, on the other; or alternatively, those of Tatlin, Malevich, and Lissitzky could definitely assert that the first was Soviet art, the second, non-Soviet, and the third, anti-Soviet. In our troubled time, this picture loses its former clarity. The names, until recently odious, of Petrov-Vodkin and Saryan, are now being mentioned in the same breath with the founders of socialist realism. Formerly fanatical advocates of formalism have become no less fierce supporters of the principles of realism.[1] At official Soviet exhibitions works frankly executed in the style of the twenties and even the latest Western "reactionary" trends become more and more frequent. Finally, there has appeared a notion of an "unofficial Soviet art," which earlier was absolutely inconceivable. In the peripheries of their stylistic ranges, these "official" and "unofficial" tendencies merge to such an extent that it is no longer simple to draw a distinct demarcation line between them.

Projecting these tendencies into the future, one might easily come to the optimistic conclusion that in about ten years socialist realism will completely change its nature and will dissolve in the ever-growing stream of "unofficial art"—that the pot of nourishing fish soup will turn into an aquarium of golden fish. But before we relax in rosy optimism, we should examine the nature of the changes that have taken place in Soviet art during the past twenty years and examine the stylistic structure and content of Soviet art in both its official and its unofficial varieties.

## Official Art and Early Opposition

Among the features of Soviet art, one should differentiate between the artistic features—the features that belong to the structure of the concrete work of art and respond to stylistic analysis—and the dogmatic features, which fall outside the bounds of this structure. These latter include

*Translated by Rimma Vinnikova and Alison Hilton

partiinost (adherence to Party principles), narodnost (national or folk character) or, more precisely, massovost (mass character), realism and other categories of Marxist-Leninist aesthetics. The principles of partiinost and massovost influenced the creative work of such stylistic opposition as Tatlin and Tomsky, Lissitzky and Gerasimov, Rodchenko and Nalbandyan. The category of realism is not precisely formulated in any aesthetic statement; in some cases Soviet ideology drove it into the narrow channel of political doctrine, in others it spontaneously overflowed its banks. As far as artistic features are concerned, they may be the direct effects of a work of art on a spectator, based on a combination of stylistic elements; in short, its emotional, evocative structure.

From the dawn of Soviet artistic culture, the optimistic and life-asserting element was propounded as the basic and compulsory positive tone of proletarian art. The revolutionary futurists called their art "a factory of optimism;" socialist realism confirmed this attitude by demanding the "truthful depiction of typical (or positive) aspects of Soviet reality in their revolutionary development." The impetuous crescendo of social optimism permeates the bravura symphony of Stalinist socialist realism. This crescendo defines the genesis of social optimism and forms the kernel of the emotionally evocative structure of works created according to Soviet prescriptions.

The artistic opposition that arose within the official sector of Soviet art in the mid-fifties was directed not so much against the dogmatism of socialist realism as against its bureaucratic optimism in the interpretation of reality. At that point, only a few of its representatives denied the principles of partiinost or narodnost in art. On the contrary, following these principles, they aspired to depict reality in the austerity of its drab routine, in its tragic collisions, in the dramatic confrontation of its contradictions (an analogous process takes place in the literature of those years—from Ehrenburg and Dudintsev to Solzhenitsyn). This opposition left its imprint on all of Soviet art of the late fifties and early sixties. Soviet art criticism has recently established the term "tough style" for the definition of this period.

It was the works of this tough style which first aroused Khrushchev's anger in 1962. With unerring Party instinct, he sensed in the absence, or rather in the inadequacy, of social optimism in these works an impermissible departure from the fundamental principles of Soviet ideology and a gross violation of the rules of the game. From that moment there began a successive and methodological campaign to eradicate the tough style. The delicate conclusion of a prominent Soviet critic sums up a ten-year process.

The early works of such impressive masters as Pavel Nikonov, Tair Salakhov, the Smolins brothers, Mikhail Savitsky, Nikolai Andronov, Dmitry Zhilinsky, Edgar Litner, Ionas Shvazhas, Togrul Narimanbekov and others, belong to this tough style. However, all these artists reached their creative zenith only when the tough style was past. Not only its evocative means, but also its

poetic horizons appeared to be limited because of an insignificant scale of ideas. A certain spiritual narrowness and stiffness of imagination were revealed through the prosaic ostentation of everyday life. All this generated dissatisfaction which soon had practical results. [2] Here one can discern the real forces that direct this process: the "dissatisfaction" of ideologs caused by the "stiffened imagination" of these artists (indeed, in order to see a source of special joy in Soviet reality, one needs a very flexible and mobile imagination) brought about the "practical results" of rooting out the elements of the "tough style" from Soviet art and inculcating pure optimism. Eventually, the active role in this eradication was played by the tough artists themselves. Having entered the stream of general optimism, they poured into the current of stormy jubilation. Achieving creative maturity they got their due titles and posts. Those among them who remained true to their ideals (the more significant artists—Neizvestny, Birger, Sidur, and others) were thrown overboard and added to the ranks of unofficial artists.

### Changes in the Seventies

The visual results of this evolution—that is, the character of Soviet art of the seventies—can be described in the words of another Soviet critic: "The social content of the song being composed in our painting cannot be in doubt. But it now takes on more complex features; it expresses a feeling of surprise and delight before life and before man." [3] And further: "A tinge of traditional hedonism is combined with a broad outlook on the world, to show the inner state of a man in full harmony with real life, joyfully accepting routine as a holiday. In this psychological openness lies the moral position of the modern individual." [4] From the severity of socially tinted daily life to a sphere beyond social concerns, and then from a "celebration of the routine" and a "surprised admiration before life," to complete conformity with surrounding reality as the "moral position" of an artist: this is the main line of development in Soviet art of the last two decades. However, the progression along this line has entailed noticeable losses for orthodox socialist realism.

The first thing that will strike the eye of someone who has been out of touch with the practice of Soviet art for the past fifteen years is a noticeable reorientation away from the stylistic legacy of the *Peredvizhniki* (a group of mid-nineteenth century Russian realist artists with democratic tendencies) and the AKhRR (the Association of Painters of Revolutionary Russia) toward the stylistic traditions of the second half of the twenties as exemplified by the OST (Society for Easel Artists), the "October" group, and other artistic groups. The styles of the posthumously rehabilitated Petrov-Vodkin, Yakulov, Luchishkin, Samokhvalov, Pimenov, and Deineka, with their striking use of color, mixture of spatial planes, and unconventional perspective, became the casual language featured at recent Soviet exhibitions, and was given condescendingly benevolent notice in the leading Soviet art journals. These styles introduced a certain external variety into the once monolithic stylistic entity of socialist realism. Moreover, from time to time at the same exhibitions there appeared half-abstract compositions and works along the lines of pop art and American hyperrealism, absolutely criminal from the viewpoint of ideology. Strangely enough, such innovations have won their right to exist for the time being, if only in one specific field—the depiction of Soviet cosmic achievements. [5] Huge collages and photomontages combine different temporal and spatial planes in one and the same work along with surrealistic alogisms and conceptual formulas. If we replace pictures of rockets, cosmonauts, and atomic structures with soup cans, movie stars' portraits, and traffic signs, we will get almost precise copies of the early works of Andy Warhol. Or, conversely, if we inject into the dreary outlines of Eduardo Paolozzi's interplanetary machines a huge dose of civic pathos and optimism, we could observe a curious instance of metamorphosis from bourgeois pop art into Soviet cosmic realism.

Nevertheless, the recent broadening of the stylistic scope of Soviet art is taking place chiefly through the repetition of the devices and methods of the "heroic realism" that followed the post-avant-garde art of the twenties. The appeal to this source, the attempts to reanimate its style and spirit, are as natural as they are futile. They are natural, because this art reflects the cheerful and joyful spirit of the twenties, with its romantic image of labor and struggle and its optimistic belief in a future national happiness. This is something which has evaporated almost without a trace from Soviet reality. Social optimism now is as scarce a commodity as meat and bread were in the twenties and, in contemporary Russia, to find a person "welcoming routine as a holiday" is as hard as it would have been to find a sated man in the years when the canvases of socialist realists were bursting with a display of abundance. By rooting out the tough style, Soviet art was just carrying out the task of making good this social deficit.

If the masters of OST and "October" translated the intense perceptions of their time into a language of forms and created a distinctive style, that which now keeps members of the Union of Soviet Artists busy is a farce. It is as if Soviet art descended from the solemn pedestal of dogmatism to the stage of the variety show (socialist style) where, lit by varicolored spotlights, it entertains the public with color effects and compositional tricks. Those in charge of socialist realism shut their eyes to these tricks and effects in order to preserve an illusion of a general satisfaction and joy, to preserve the main feature of any totalitarian art—its social optimism. It is precisely here, not so much in stylistics as in an attitude toward life, that we can now see the boundary which separates official from unofficial art; the one encouraged and thriving, the other half-forbidden and persecuted, but nevertheless a vigorous stream in the current of the Soviet Union's artistic life.

### The Internal Development of Unofficial Art

In twenty years, unofficial art in the Soviet Union has already passed through several stages. In tracing the line of its evolution, it is important to bear in mind not a chronological sequence of stylistic innovations but the "internal task" which predominated at each of these stages.

Unofficial art, even at its earliest stage, stood in polar opposition to socialist realism, even more so than the tough style. But it grew out of the same soil of general aesthetic notions of its time, and did not go beyond the concept of art as a "form for the reflection of reality." At first, its opposition to socialist realism took the path of choosing different aspects of reality to reflect. Instead of the joy and severity of our everyday life, always directed toward the future, it offered the grotesque absurdity of the individual's existence in a timeless world; instead of admiration before the beauty and wealth of the material world, it upheld a striving to preserve spiritual values, to penetrate into aesthetic, ethical, religious, and other inner strata of life. As a result, it replaced

a superficial social optimism by a profound existential pessimism. To socialist realism it could oppose a different realism, a fantastic realism, a realism of metaphor and the grotesque.

The notion of style at this stage was confined primarily to representational forms ranging from surrealistic alogisms to expressionistic hyperboles. Attention to style revealed the incompleteness of the development of a realistic cycle of Russian art, which was first suppressed by the revolutionary avant-garde, and later distorted by socialist realism. At this stage, unofficial art arose spontaneously under the conditions of a cultural vacuum and a lack of information about Russian art of the 1910-20s, let alone artistic life in the West. That is why it is difficult to talk (as is frequently done by Western observers) about direct influences, not to mention borrowings. But one can identify the ancestors of today's avant-garde: artists like Chagall, Filonov, Kandinsky, and the "Makovets" group (the "Union of Artists and Poets, Art and Life," formed in 1922); artists belonging to the most spiritual strain of early twentieth-century Russian art; and also some Western surrealists and expressionists.

The development of an unofficial art in the Soviet Union took place under specific conditions: the cultural vacuum that existed in the country during the long years under Stalin was ready to absorb the atmosphere on the other side of the iron curtain. By the end of the fifties, at least in Moscow, artistic circles were exposed to ideas and creative concepts that were new to the Soviet people. The theories and practices of the Russian and Western avant-garde of the early twentieth century and the latest foreign trends enjoyed increasing circulation. The task of "reflection of reality" became secondary to the principle of "creating a new reality and new creative concepts." This stage was characterized by a widening of the stylistic range and an increased dynamism in its development. In a strikingly short period, the same artists and groups covered the distance from Russian constructivism to pop art, from ideas of production and life-building to Western happenings, from abstractionism to conceptualism. This process takes unofficial art as far as its third stage, which began with the seventies.

At this stage, unofficial art began to flow into the worldwide current and became synchronous with modern Western culture. Perhaps its present "internal task" can be defined as one more reorientation: from an art that creates artistic values to the creative act as a manifestation of abstract freedom. At this stage, the direction was set chiefly by the artists of a new generation, who became active in the mid-sixties. Their opposition was directed not only against socialist realism but also against the retrospective styles of their predecessors in the earlier stages of unofficial art. This was a kind of liberation from the past, clearing the way for future, yet unknown, constructions. At this point, Soviet unofficial art unites with radical Western trends. But in the West, in a society which has traditionally been ready to accept almost any innovations in art, the affirmation of freedom as an absolute value by artistic means is a natural gesture. In the Soviet Union this is a gesture of extreme determination and despair. It demands much greater exertion of spiritual and creative efforts. Thomas Mann wrote that "good works appear only under the pressure of bad life." These words perfectly suit the conditions of art in the USSR and instill some hope for the future of unofficial art. Meanwhile, the forms of aesthetic freedom are at present being created in the West. The new Soviet avant-garde artists must follow the steps of their Western colleagues.

In this rather approximate scheme, I have deliberately not cited examples or names. But to review the stages of development with typical examples, we may point to the works of Rabin and Sveshnikov for the first stage; to the works of Kabakov, Yankilevsky, and the painters of the kinetic art group *Dvizhenie* for the second stage; and to the "*sots*-art of Melamid and Komar, painters "hatching out eggs," and the authors of *The Coat of the Painter Odnoralov* at the semi-official exhibition of Moscow painters in September of 1975 for the third stage.

If we accept this scheme as a starting point, then it is not difficult to make some predictions for the future. It is very unlikely that future unofficial art will orient itself on the forcibly disrupted tradition of Soviet revolutionary avant-garde of the twenties. Those aesthetic discoveries were taken up, developed, and already realized in the West, while its revolutionary ideology was usurped, distorted and turned into political demagogy by socialist realism. Unofficial art has already passed the initial stage of mastering the concepts of the early avant-garde, and now it derives its creative stimuli from the living, ongoing practice of art, for which the ideas of the revolutionary avant-garde were sources in their own time. In the future, unofficial art will evidently draw closer to Western trends, and the process of its stylistic development will be determined by aesthetic patterns shared by the twentieth century's cultures. However, it is impossible to talk about the future of unofficial art in isolation from the general development of Soviet artistic culture.

During the last fifteen years, the existence of unofficial art in the Soviet Union became a real fact. Thanks to Western and domestic collectors, it won a serious audience and a limited access to the Western art market. Its existence was at least registered in the public mind. In such ways it acquired an aesthetic, social, and material status—unstable, but real. A completely new situation in the artistic life of the country is the result. Here, for the first time in fifty years, the artist is confronted with the possibility of a real choice. He may join the sphere of official activity and win material benefits, a place in the hierarchy, and access to closed sources of information, but by this path he excludes himself from the stream of contemporary art and risks losing his creative potential. Or he may take the path of unofficial art. Finally he may occupy an intermediate position, supplying the official exhibitions with one kind of work, and for himself creating something quite different (the last variant is, probably, the most widespread). For the painters who have something to lose, this choice turns into a variant of Hamlet's question, one of professional existence. We have witnessed a drain from the official sphere of the most talented and original masters—Neizvestny, Weisberg, Birger, Sidur—and they are only the most vivid examples of this process.

Soviet authorities can keep silent about this situation, but they cannot simply forbid it, and they cannot avoid taking this process into consideration. This explains certain changes in official policy in the field of art, which have occurred during the past two and a half years, and which optimists hasten to call "liberalization." On the one hand, those in authority can no longer withstand the pressure from below, and being unable to suppress it, must allow episodic exhibitions of unofficial art (with complete silence about them in the press and other media). On the other hand, they try to bring unofficial art under control and to include a certain part of it in the official sphere. It is with this purpose that the City Committee of Moscow artists has recently been founded to bring together some of the unofficial masters, chiefly from the older generation, and make them fill a buffer function between the controlled MOSSKh and the stream of uncontrolled creativity. Meanwhile, official painters obtained the right to amuse themselves with formal innovations and this creates an illusion of a certain movement ahead.

## Prognosis

Does all this mean that the dogmatism and stylistics of socialist realism have entered into irreconcilable contradictions, that a rift has appeared between its center and its outlying areas, and that this fracture will widen in the course of time and define the future course of Soviet art? In order to glance into the future, one should look back at the immediate past. We are not obliged to stir the dusty accumulations of the archives of history. It is enough to ascend the steps of the hierarchy of Soviet culture—from the showrooms and studios of painters to the studies of functionaries, academicians, ideologists, aestheticians. Here we discover not the ghostly shadows of our past but its living flesh, the same ideas and the same people. It is enough to look through their general reports and summarized works—where on each page we come across the statements of old authorities, as revived by the new leaders, about the *partiinost, narodnost,* and realism of Soviet art, its propagandist nature, its unique position on the very peak of the human cultural evolution—to realize that socialist realism for the past twenty-five years has not recanted its single dogma and has not changed its totalitarian nature.[7] The stylistic changes we have discussed have taken place only in the fringe area of socialist realism; in its core, it preserves the same artistic vocabulary and organizational structure that it had in Stalin's time. It seems possible, assuming the preservation of some stability in the field of art, that the outlying area of socialist realism will expand and its conventions will change as it soaks up the elements of decorative abstraction, ideologized surrealism, and utilitarian constructivism—tendencies which exist even now. But never, under any circumstances, will it give up its main task—to propagandize a fundamentally joyful Soviet reality whatever gloomy forms this reality assumes. It will never compromise even with such palliatives as the tough style of the late fifties and early sixties.

Thus, Soviet art is now developing by way of a close interaction of two counteracting elements: official and unofficial art. Official art, thoroughly cherished by the state, long ago finished its historical cycle, but has existed by means of artificial feeding—like Lysenko's cows on condensed milk. If deprived of artificial nourishment, it will fade away, just as analogous formations faded out in Germany and Italy with the collapse of totalitarian regimes after the Second World War. Unofficial art, on the other hand, appears as a natural growth of the seeds that were buried in the soil for several decades but did not spoil and are now sprouting. The once powerful monolith of socialist realism is now being eroded by the flood of the opposition, which carries away its ruined layers, sucks out their contents into its own substance, and sometimes sweeps up to the surface its horrid remnants in the form of Rabin's grotesques, or Kabakov's sarcasms, or the "reverse images" of Tselkov or Sveshnikov. But even the ideologically hard-baked soil of official art begins to soak in moisture, and a weak but still living vegetation begins to emerge through it.

Now unofficial art is rapidly going through the disrupted and incompleted cycles of the previous development of Russian art, and simultaneously is being drawn into a Western cycle, from which it was separated by a blank wall for many years; hence its eclecticism and stylistic inconsistency. Before it lies a whole continent of vital material and experience, which has not undergone aesthetic processing in the mechanism of culture; a rich set of still unused methods and tools. Before it waits a sensitive audience of many millions, yearning for contemporaneity. In this lies the potential of its further development. If we turn to an historically analogous period—the heroic period of Russian art in the first two decades of our century—we can see prophetic visions of important discoveries, anticipating their time, which may now have come.

But to realize this potential, art must be left to develop under natural conditions. It is the struggle to achieve these conditions that now defines the social character of the artistic opposition in the Soviet Union. The fight is unequal, because the state has at its disposal enormous means of material encouragement and mass information, and holds in reserve a powerful apparatus of suppression. On the side of the opposition is a natural and organic process of development, which involves ever growing numbers of creative individuals.[8] As long as unofficial art remains before the public conscience both inside the country and outside, so that the Soviet regime must take it into consideration, these processes will continue and expand. At the present time, unofficial art has won only the right not to be destroyed. It is erroneous to call what is now happening in the Soviet Union "liberalization." It is only a tactical move, a concession to detente, a small thawed patch on the surface, under which there lies a thick permafrost layer of official ideology.

To speak about the distant future means to define the socioaesthetic nature of Soviet art. Socialist realism was not only a brilliant invention of Stalin, Gorky, and Gerasimov; if we consider it in the general context of the artistic culture of the twentieth century, it will turn out to be a national variant of an international totalitarian art. Socialist realism can be defined as an art pertaining to the advanced stages of totalitarian regimes. During the twentieth century, we witnessed the emergence of identical phenomena in Soviet Russia, Nazi Germany, and Fascist Italy.[9] Socialist realism is a closed system possessing its own style, aesthetic ideal, and organizational structure. It finds its nourishment and support in a mass totalitarian conscience. It is indeed a kind of emanation of this conscience, its projection into the aesthetic sphere. And one does not have to be a prophet to foresee that whenever and in whatever part of the world a new totalitarian regime appears, it will generate an aesthetic of socialist realism and will make it a model for compulsory imitation (at present, such a process is taking place in Communist China).

Soviet unofficial art will probably preserve its values as a part of a twentieth-century pan-European artistic culture. In the course of time, when the chronological priority of formal innovations loses its significance, the art of the twentieth century may be re-evaluated according to the degree to which it reflects historic and human values. Then future generations will, perhaps, discern in the works of Soviet nonconformist artists something that will allow them to understand better their spiritual past.

**Notes**

[1] Such transformation, for example, has recently occurred with N.N. Punin in the collection of his works, N.N. Punin, *Russian and Soviet Art* (Moscow, 1976).

[2] A. Kamensky, "Context of Style," *Iskusstvo,* No. 3 (1977), p. 6.

[3] G. Pletneva, "Social Moral Questions of Contemporary Life in a Picture of the Seventies," *Iskusstvo,* No. 11 (1976), p. 113.

[4] *Ibid,* p. 6.

[5] In the USSR in 1975-76, there were two exhibitions of art on cosmic themes, "executed by painters in a specialized creative group." See I. Chernevich, "The World of a Tangible Dream," *Iskusstvo,* No. 4 (1977), pp. 6-14.

6 For example, the Academy of Social Sciences recently published the collection *Art and Ideological Work of the Party* (Moscow, 1976).

7 Lately Soviet art theoreticians have made more and more frequent references to the following statement by Brezhnev, which is worth quoting as a whole, because of its categorical straightforwardness: "The main thing that makes us strong and gives us a decisively offensive position in the ideological struggle is the great truth of historic development, which is on our side, and is represented specifically by us—our socialist order, our program of building of Communism—all those ideals for which we struggle. It is our task to make this truth understandable and comprehensible for hundreds of millions of people, including those outside of our socialist world. And here—along with our propaganda, our journalism, and our social sciences—art can do a great deal." L. Brezhnev, *On the Communist Upbringing of the Working People* (Moscow, 1974). All these slogans were repeated in Suslov's speech on awarding the order of Lenin to the Academy of Art of the USSR on December 26, 1975. Suslov was answered by the President of the Academy, Tomsky, who assured the Party and comrade Brezhnev personally "that Soviet art will henceforth move forward on the road of socialist realism, to which not only the present, but also the future, belong." This meeting of two of Stalin's hawks in the mid-seventies, at the apex of the Soviet official cultural hierarchy, is an ominous symbol of the real situation in Soviet art.

8 On the rate of the numerical increase of unofficial painters see Igor Golomshtok and Alexander Glezer, *Unofficial Art from the Soviet Union* (London, 1977), p. 104.

9 See I. Golomshtok, "The Language of Art Under Totalitarianism," *Kontinent,* No. 7 (1976).

PLATES

**Ely Bielutin**

49
*Woman and Child* 1973
Oil on canvas
95 x 79.5 cm.

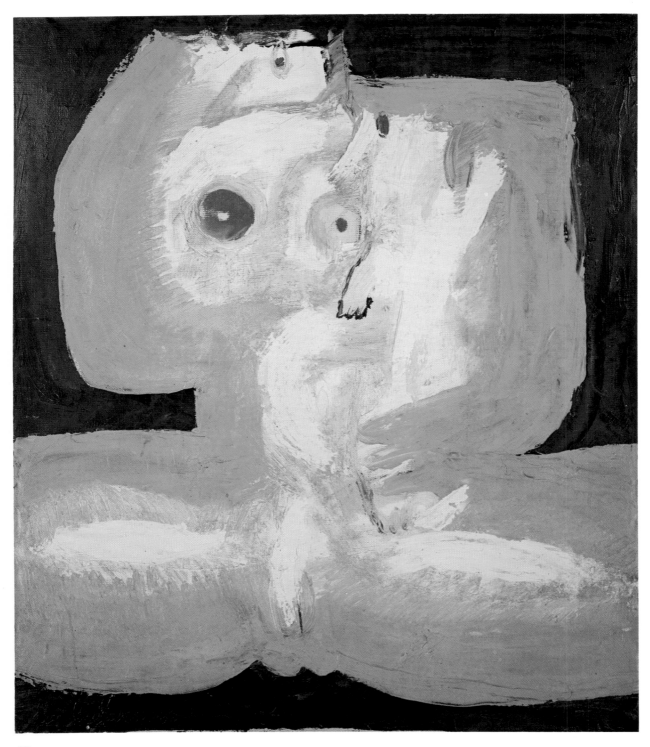

**Yuri Dyshlenko**

50
Untitled
Series of five 1975
Oil on canvas
75 x 60 cm. each

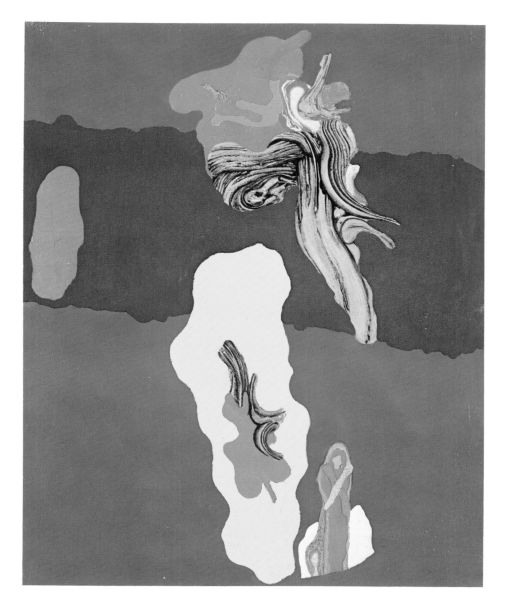

**Alexander Kharitonov**

51
Untitled 1972
Oil on canvas
27 x 37 cm.

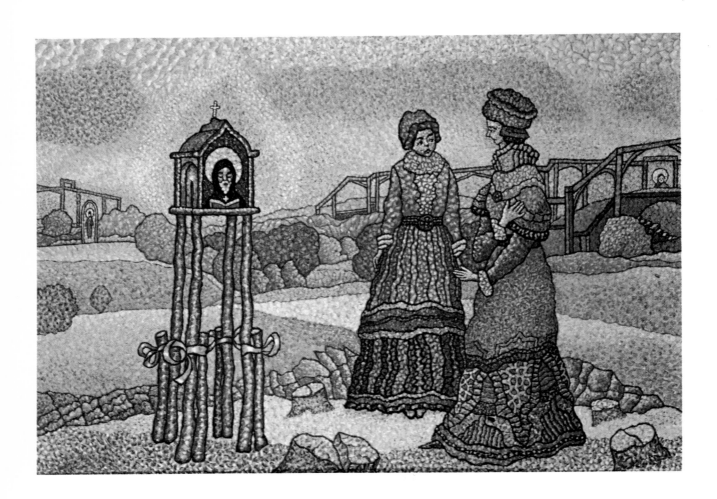

**Komar and Melamid**

52
*Plan for a Blue-Smoke Producing Factory* 1976
Oil on Canvas
213 x 100 cm.

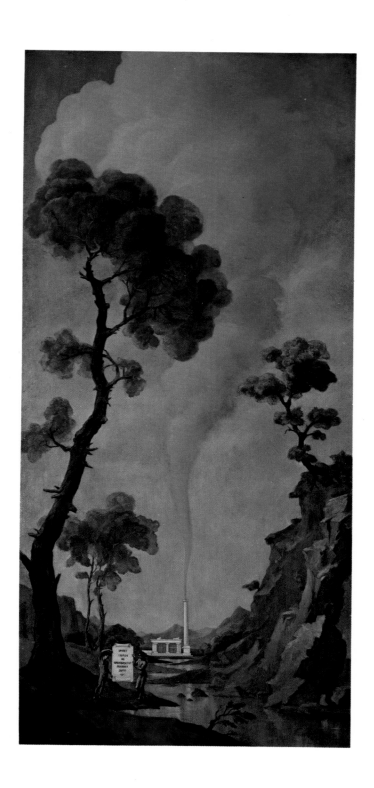

**Malle Leis**

53
Untitled 1975
One of a series
Serigraph
61 x 61 cm.

**Raul Meel**

54
*Sous le Ciel Estonien* 1973
One of a series
Serigraph
65 x 63 cm.

**Evgeny Mikhnov-Voitenko**

55
Untitled 1976
Gouache
75 x 56 cm.

**Vladimir Nemukhin**

56
*Poker on the Beach* 1974
Oil on canvas
67.5 x 79 cm.

**Vladimir Ovchinnikov**

57
*Playing Volleyball* 1976
Oil on canvas
83 cm. diameter

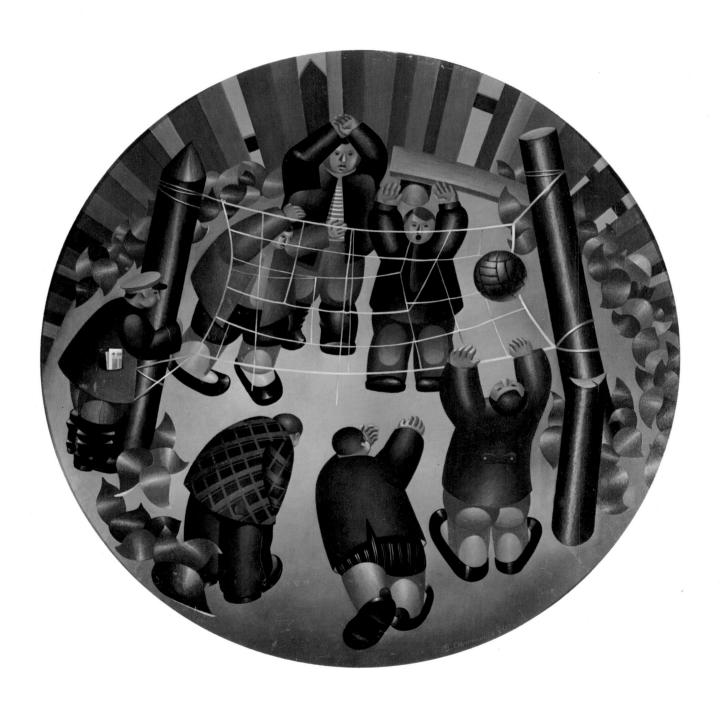

**Oskar Rabin**

58
*Window over Moscow* 1975
Oil on canvas
110 x 100 cm.

**Igor Ross**

59
Untitled 1974-75
Oil on canvas
120 x 60 cm.

**Samuil Rubashkin**

60
*Passover* 1973
Oil on canvas
100 x 80 cm.

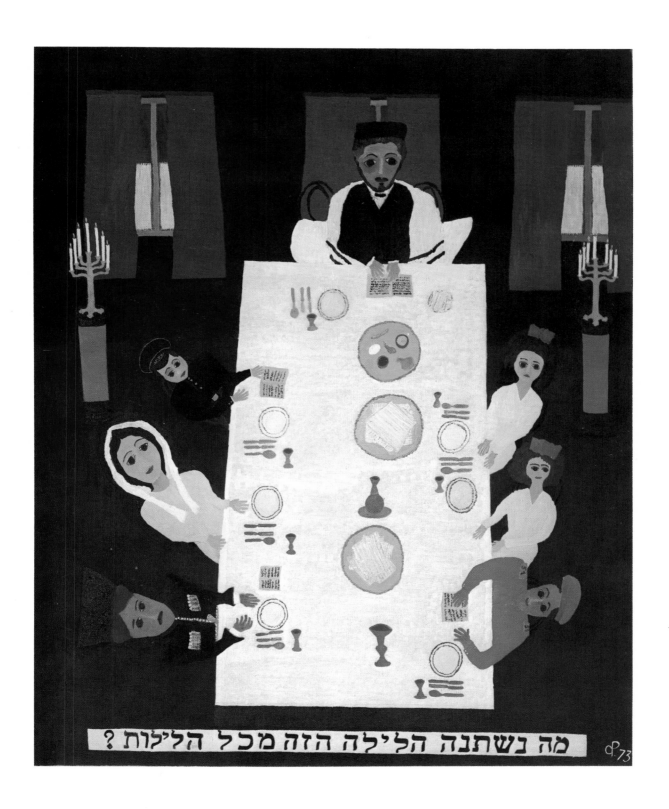

מה נשתנה הלילה הזה מכל הלילות?

**Edward Shteinberg**

61
*Composition* 1976
Oil on canvas
114 x 70 cm.

**Boris Sveshnikov**

62
Untitled 1976
Oil on canvas
109.5 x 49.5 cm.

**Igor Tiulpanov**

63
*The Mystery* 1976
Oil on canvas
40 x 200 cm.

Two fragments of above

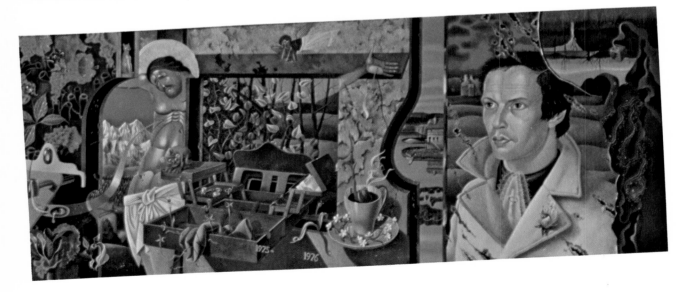

**Oleg Tselkov**

64
*Falling Mask* 1976
Oil on canvas
120 x 80 cm.

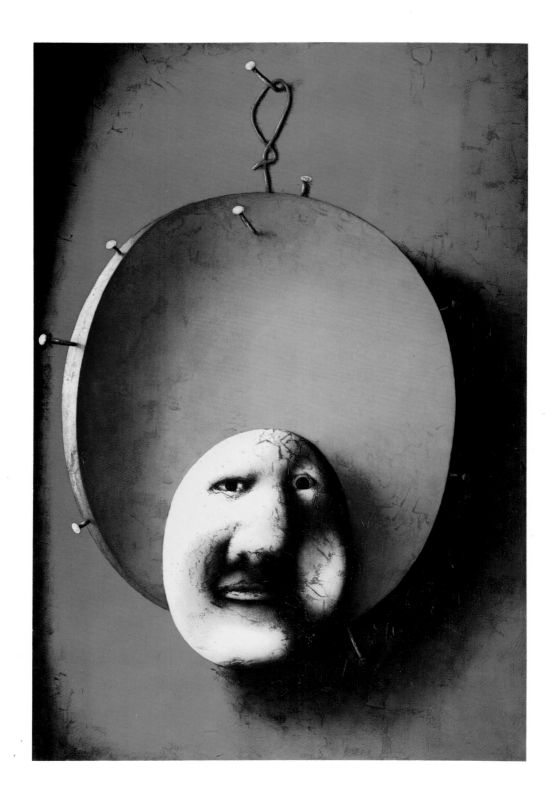

**Yuri Zharkikh**

65
*Portrait* 1974
Oil on canvas
119 x 79 cm.

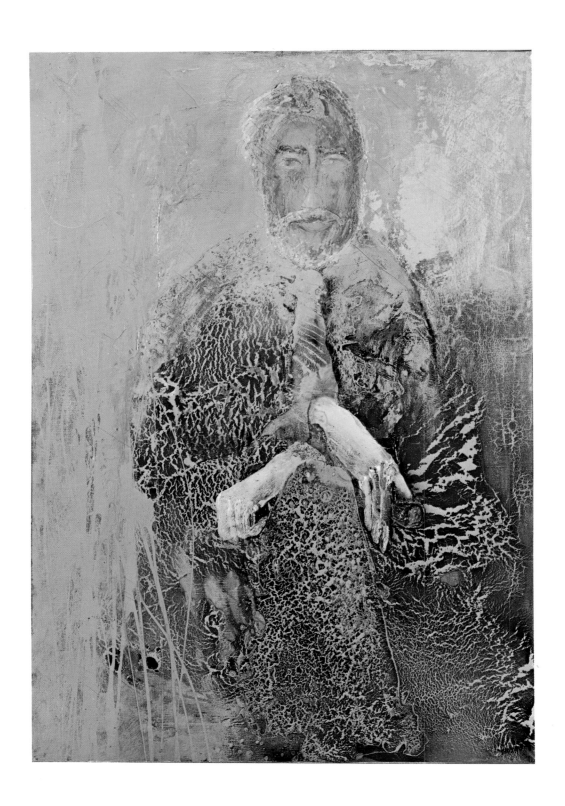

**Boris Zhutovsky**

66
Untitled 1976
Two of a series of ten
Mixed technique
86 x 26 cm. and 86 x 31 cm.

**Vladas Zilius**

67
Untitled 1974
Oil on canvas
150 x 150 cm.

**Evgeny Abezgauz**

68
*Adam Ate and Ate of the Fruit that*
*Eve Gave Him but Knew Nothing* 1975
Oil on pasteboard
53 x 40 cm.

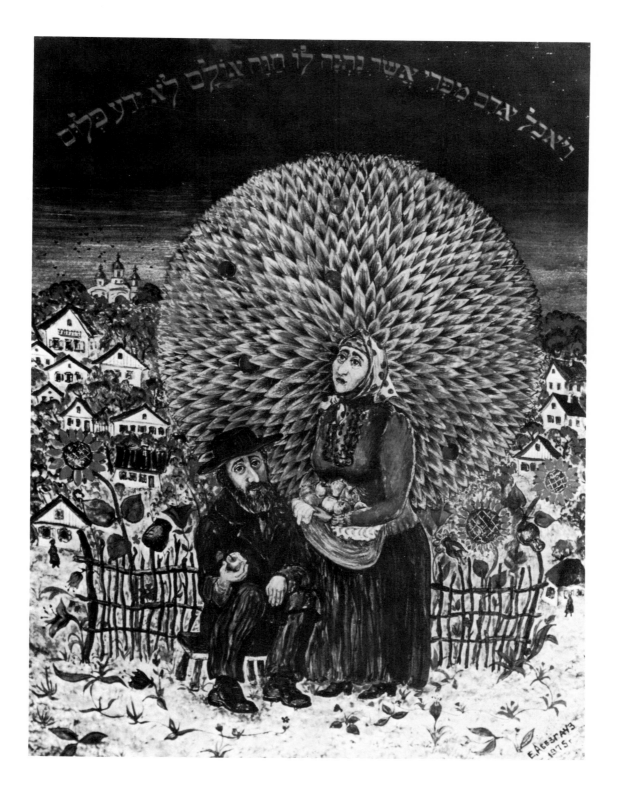

**Siim Annus**

69
Untitled 1976
From a set of seven
Ink drawing
32 x 32 cm.

**Petr Belenok**

70
Untitled 1976
Mixed technique
67 x 31 cm.

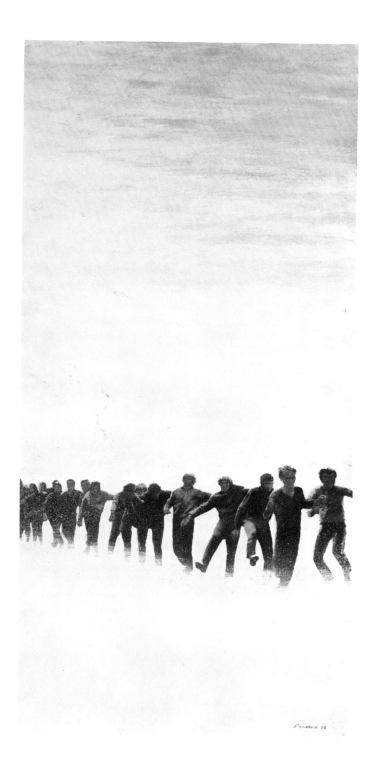

**Petr Belenok**

71
Untitled n.d.
Mixed technique
62 x 56 cm.

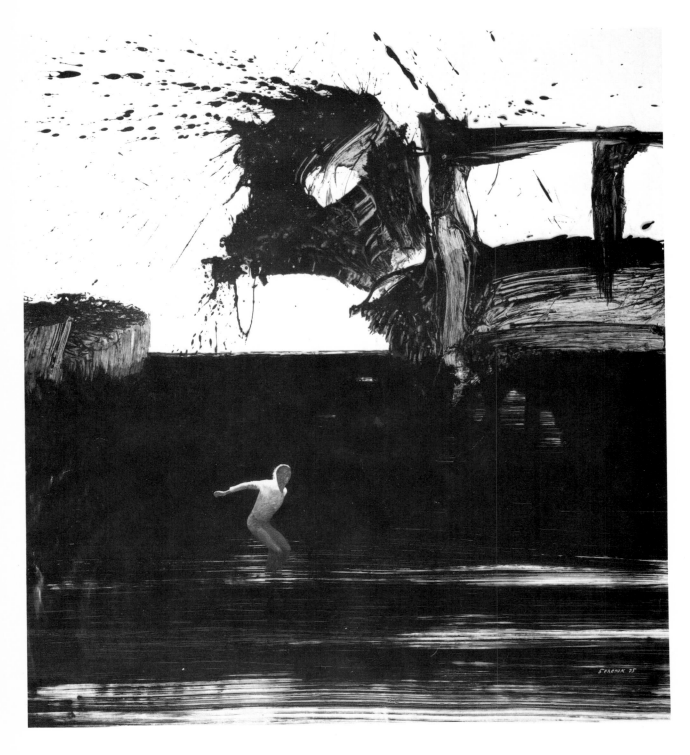

**Anatoly Belkin**

72
*Master and Marguerita* 1976
Four from a series of thirty-two illustrations
Ink drawings
22 x 14 cm. each

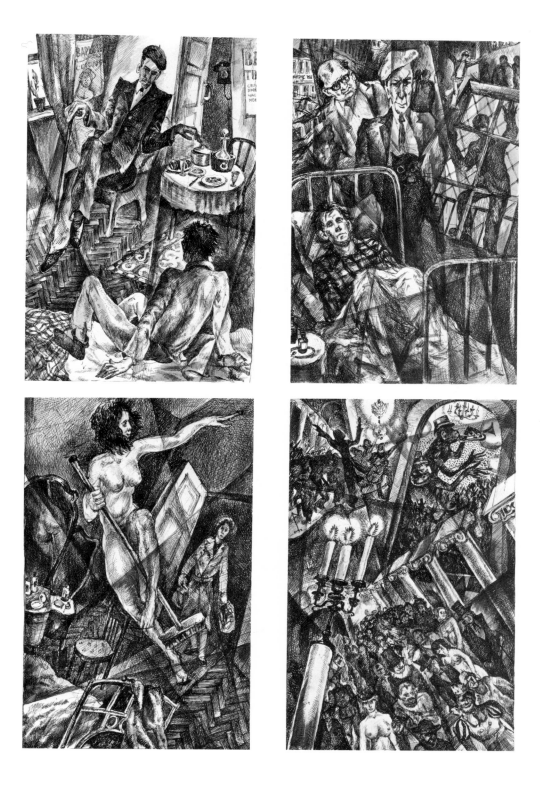

**Ely Bielutin**

73
*Madonna with child* 1975
Monotype
101.5 x 74 cm.

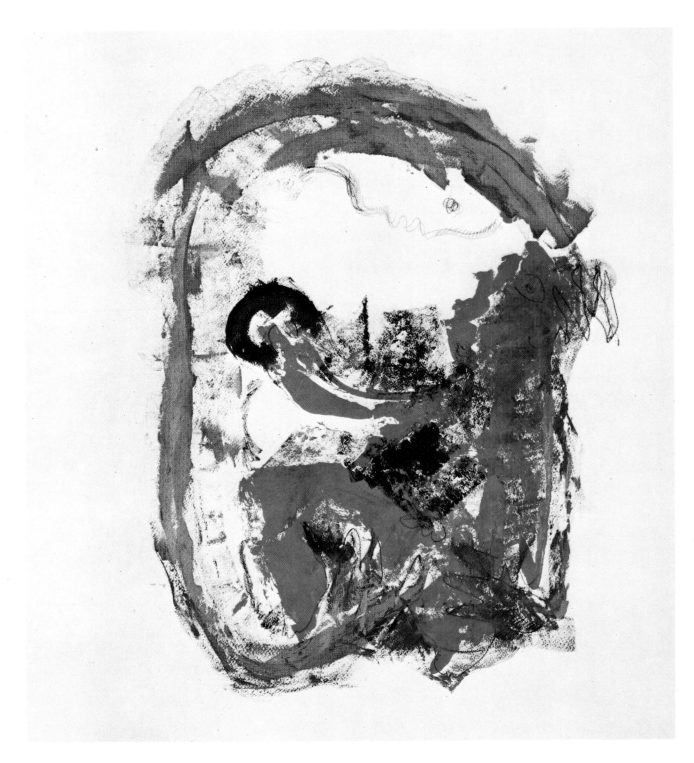

**Leonid Borisov**

74
*Composition* 1977
Tempera
20.5 x 22 cm.

**William Brui**

75
Untitled 1967
Etching
75 x 54 cm.

**William Brui**

76
Untitled 1967
Etching
75 x 54 cm.

**E. Gorokhovsky**

77
Untitled 1975
Etching
38 x 35 cm.

**Feodosy Gumeniuk**

78
Untitled 1976
Ink drawing
65 x 66.5 cm.

84

**Francisco Infante**

79
*Spiral* 1965
Two from a series of ten
Gouache
100 x 48 cm. each

**Ilya Kabakov**

80
*Shower — a Comedy*
Six from a series of thirty-nine
Mixed technique
22 x 16 cm. each

**Viacheslav Kalinin**

81
*Motif from the Story of Hoffman* 1972
Etching
65 x 49 cm.

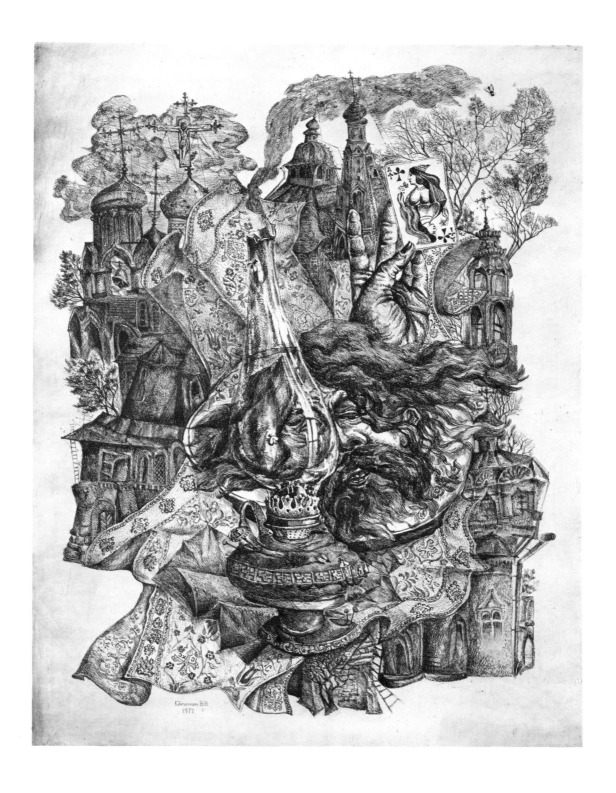

**Alexander Kharitonov**

82
*Boris and Gleb* 1975
Pencil drawing
30 x 41 cm.

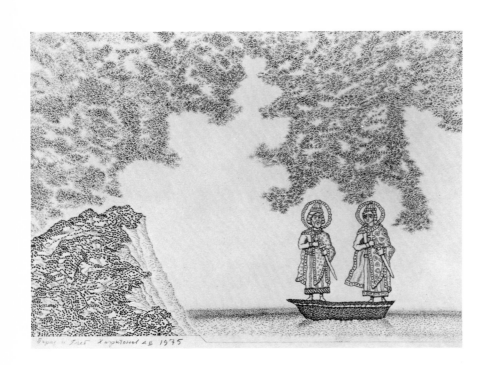

**Tatiana Kornfeld**

83
*Beloved* 1976
Oil on cardboard
48.5 x 38.5 cm.

**Dmitry Krasnopevtsev**

85
Untitled 1973
Oil on fiberboard
64 x 46 cm.

**Dmitry Krasnopevtsev**

86
Untitled 1973
Oil on fiberboard
68 x 39 cm.

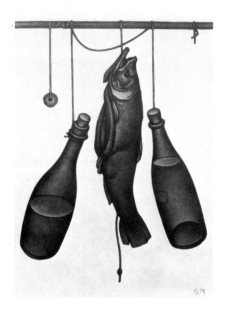

**Dmitry Krasnopevtsev**

84
Untitled 1973
Oil on fiberboard
38 x 55.5 cm.

**Oleg Kudrashev**

87
Untitled 1973
Etching
20.5 x 16.5 cm.

**Leonhard Lapin**

88
*Woman-Machine XIV* 1976
Stereotype
40 x 38 cm.

**Vladimir Makarenko**

89
*Metaphysical Form* 1975
Watercolor
33.5 x 32 cm.

**Lydia Masterkova**

90
Untitled 1969
Oil on canvas
107 x 96.5 cm.

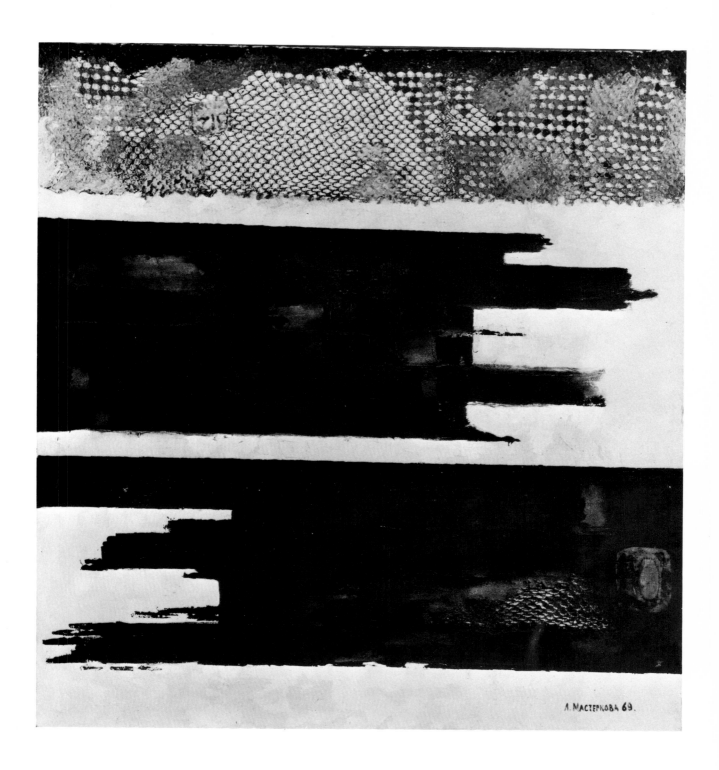

**Lydia Masterkova**

91
Untitled 1971
Oil on Canvas
155 x 107 cm.

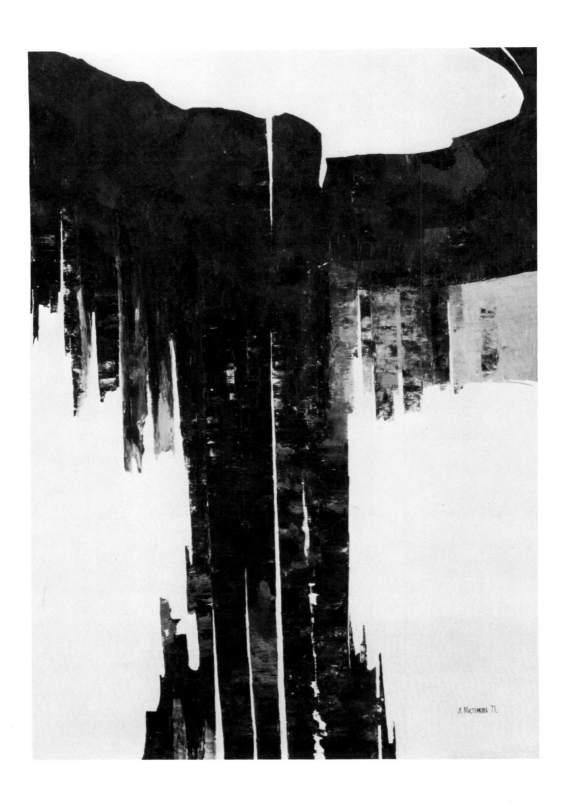

**Lydia Masterkova**

92
Untitled 1974
Oil on canvas
120 x 83 cm.

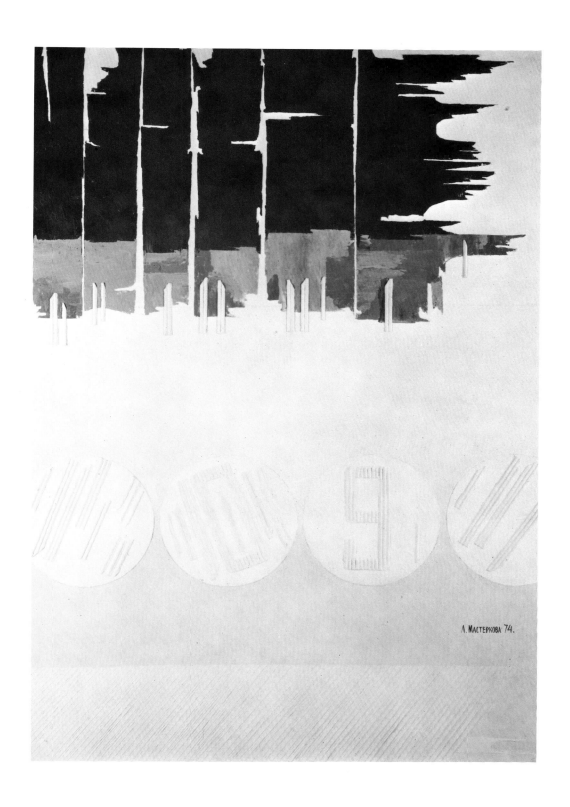

**Raul Meel**

93
Untitled n.d.
Two from a series of four
Serigraph
132 x 83 cm.

**Evgeny Mikhnov-Voitenko**

94
Untitled 1976
Gouache
56 x 76 cm.

**Evgeny Mikhnov-Voitenko**

95
Untitled 1977
Gouache
56 x 76 cm.

**Ilya Murin**

96
Untitled
Series of four 1976
Etchings
30 x 29.5 cm.

**Ernst Neizvestny**

97
Untitled n.d.
Etching
31 x 76 cm. overall, 17.5 x 12.5 each

**Ernst Neizvestny**

98
Untitled n.d.
Etching
46.5 x 75 cm.

**Vladimir Nemukhin**

99
Untitled 1976
Gouache
51 x 64 cm.

**Vladimir Ovchinnikov**

100
*Autumn Cabbages* 1977
Oil on canvas
75 x 60 cm.

**Yuri Petrochenkov**

101
Untitled 1973
Mixed technique on paper
29 x 29 cm.

101

102
*How to Depict the Life of the Soul?* 1975
Gouache and ink
41.5 x 29 cm.

**Viktor Pivovarov**

103
*Stairway of the Spheres* 1975
Six from a series of eleven
Oil on paper
56.5 x 42.5 cm. each

**Dmitry Plavinsky**

104
Untitled 1975
Etching
64.5 x 49 cm.

**Dmitry Plavinsky**

105
Untitled 1967
Oil on board
86 x 54.5 cm.

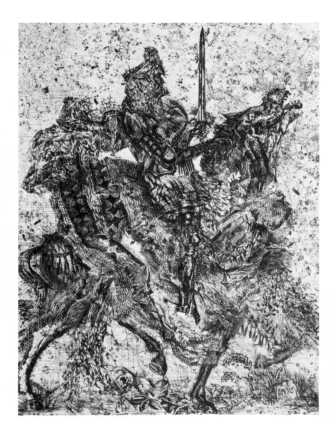

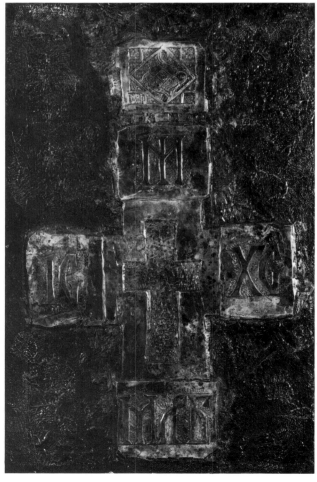

**Dmitry Plavinsky**

107
*Viking Ship Triptych* 1976
Etching
49 x 59.7 cm. overall, 49 x 19.7 cm. each

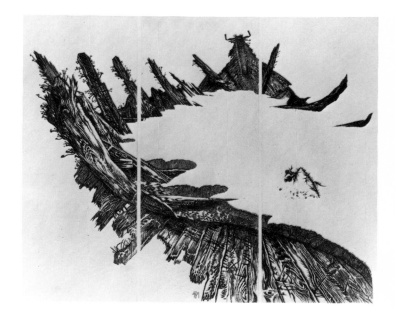

**Dmitry Plavinsky**

106
*Church of the Annunciation
in the Village near Zagorsk* 1975
Etching
64 x 146 cm.

**Oleg Prokofiev**

108
*Central Asia* 1966
Oil on canvas
79 x 63.5 cm.

**Anatoly Putilin**
109
*Albinoni* 1975
Oil on canvas
55 x 80 cm.

**Urmas Ploomipuu**

110
Untitled 1972
Etching
32 x 45.5 cm.

**Oskar Rabin**

111
*Ferris Wheel — Evening* 1977
Oil on canvas
80 x 100 cm.

**Oskar Rabin**

112
*One Ruble Piece* 1966
Oil on canvas
80 x 100 cm.

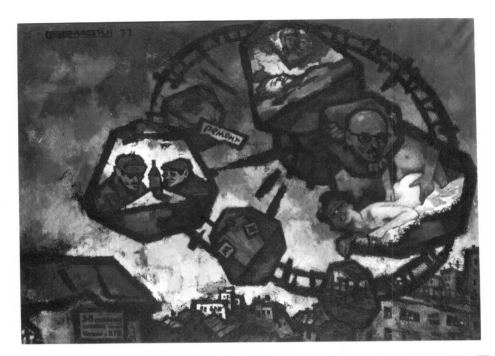

**Alek Rapoport**

113
*The Elder* 1976
Ink drawing
56 x 41.5 cm.

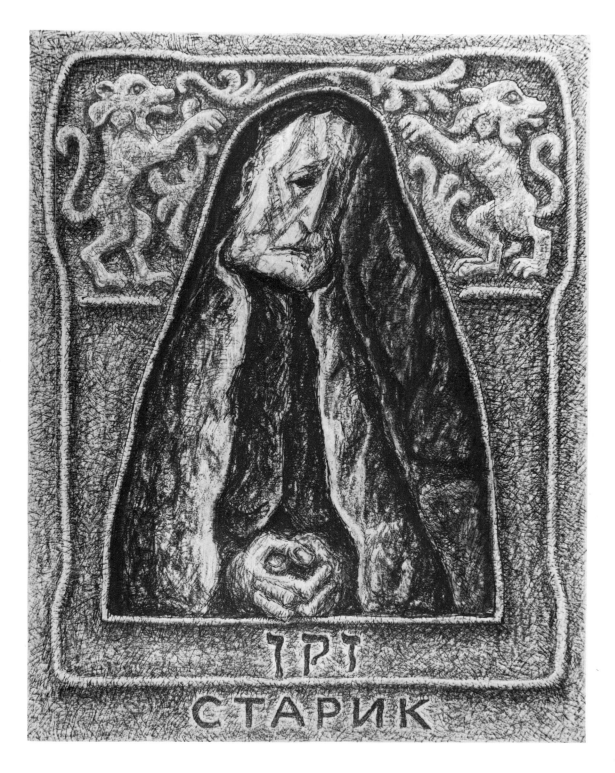

**Samuil Rubashkin**

114
Untitled 1972
Oil on canvas
95.5 x 79.5 cm.

**Evgeny Rukhin**

115
Untitled 1975
Mixed technique
99.7 x 96.5 cm.

**Evgeny Rukhin**

116
Untitled 1976
Oil on canvas
70 x 65.5 cm.

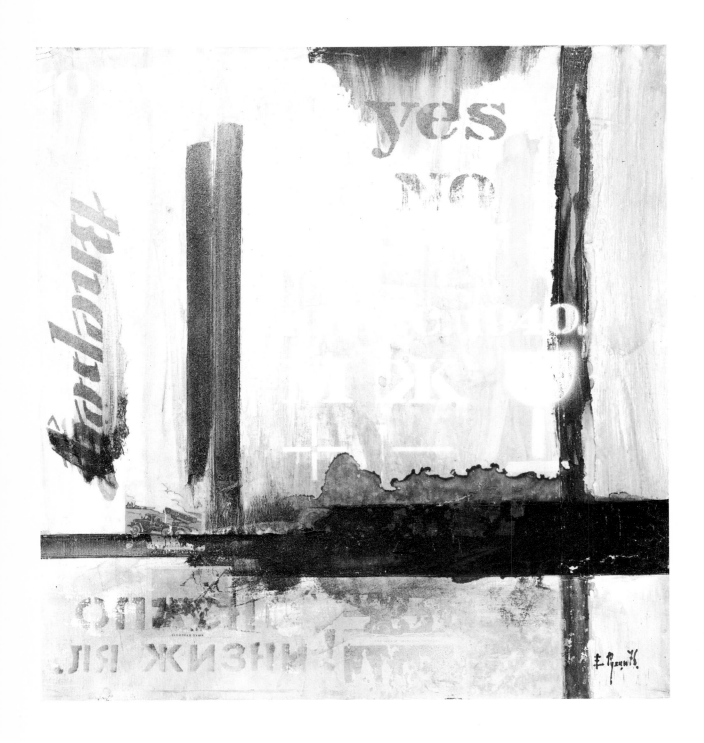

**Evgeny Rukhin**

117
Untitled 1972
Acrylic on canvas
68 x 66 cm.

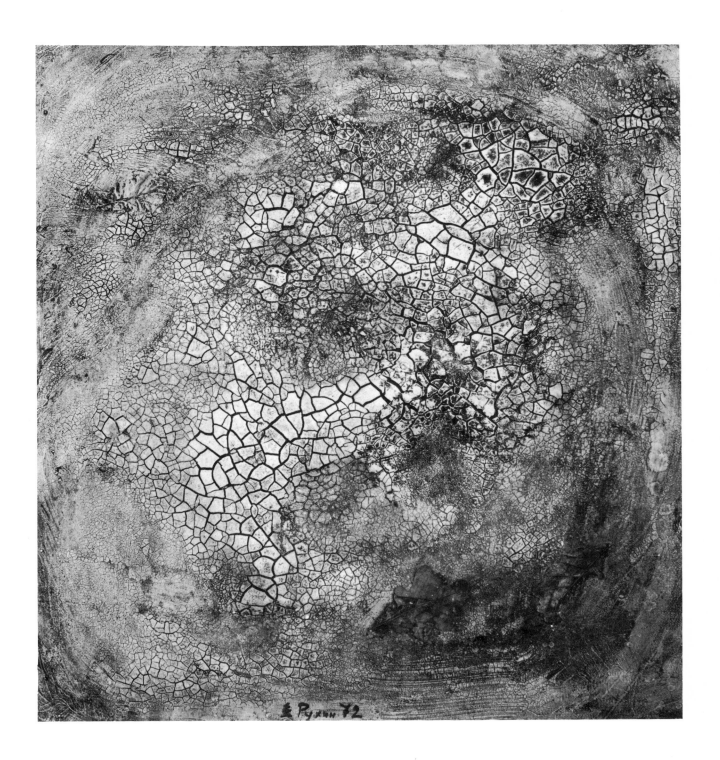

**Mikhail Shemyakin**

118
Untitled 1971
Etching
16.5 x 26 cm.

**Ullo Sooster**

119
Untitled 1953
Ink drawing
13.5 x 19 cm.

**Vladimir Titov**

120
Untitled 1977
Ink drawing
24 x 34 cm.

**Vladimir Titov**

121
*Playing with a Dog* 1977
Ink drawing
25.5 x 30 cm.

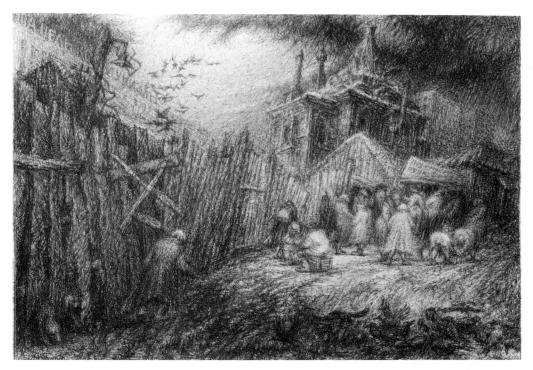

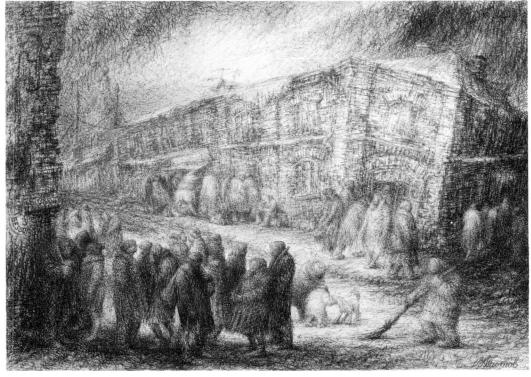

**Igor Tiulpanov**

122
*New Year, Aquarium, and I* 1970
Pencil drawing
25 x 16 cm.

**Oleg Tselkov**

120
*Acrobatic Etude* 1976
Etching
37.5 x 26.5 cm.

**Yakov Vinkovetsky**

124
Untitled 1961
Enamel on fiberboard
42.5 x 31 cm.

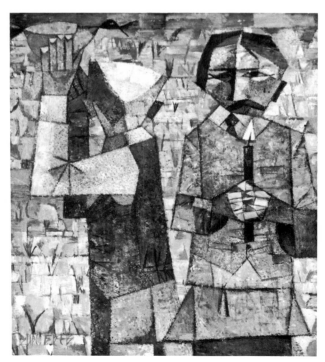

**Valentin Vorobiev**

125
*The Two* 1964
Oil on canvas
99 x 84.5 cm.

**Mare Vint**

126
*Trees and Buildings* 1974
Lithograph
36 x 35 cm.

**Tonis Vint**

127
*Room 1* 1973
Lithograph
42 cm. diam.

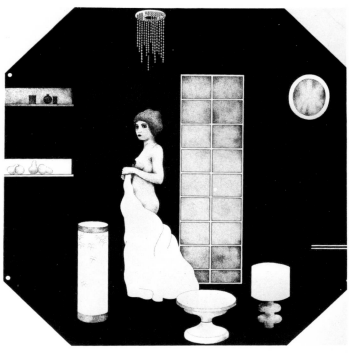

**Vladimir Yankilevsky**

128
From the album *Anatomy of the Senses* 1973
Etching
23.5 x 30.5 cm.

**Vladimir Yankilevsky**

129
Untitled 1971
Etching
49 x 63 cm.

**Vladimir Yankilevsky**

130
From the album *Anatomy of the Senses* 1973
Etching
23.5 x 30.5 cm.

**Vladimir Yankilevsky**

131
From the album *Anatomy of the Senses* 1972
Etching
23.5 x 30.5 cm.

**Boris Zeldin**

132
Untitled 1972
Oil on fiberboard
43.5 x 30 cm.

**Anatoly Zverev**

134
Untitled 1974
Watercolor
61 x 43 cm.

135
Untitled 1974
Watercolor
61 x 43 cm.

**Edward Zelenin**

133
Untitled n.d.
Mixed technique on paper
40 x 30 cm.

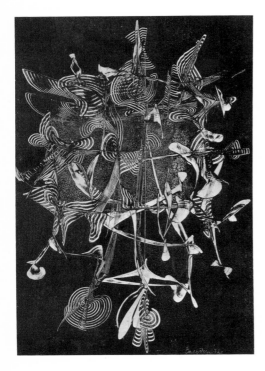

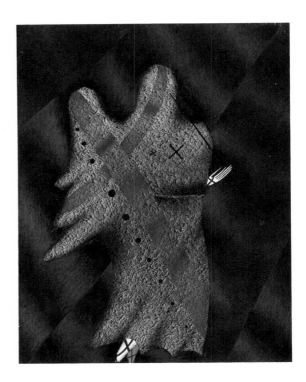

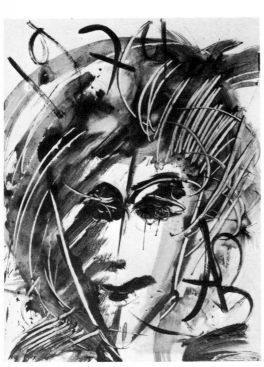

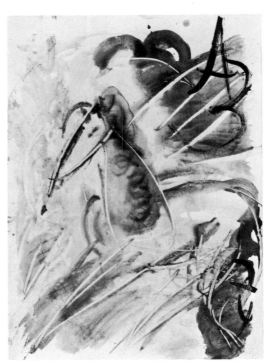

**Edward Zelenin**

136
Untitled n.d.
Mixed technique on paper
40 x 30 cm.

**Vladas Zilius**

137
*Figure of God* n.d.
Mixed technique on paper
105 x 74 cm.

# List of Artists

Name, birthdate, and major place of residence. If the artist has emigrated, his present residence is included.

**Abezgauz, Evgeny** 1939. Leningrad—Israel. Fig. 68.
**Annus, Siim** 1960. Tallinn. Fig. 69.
**Arefiev, Aleksandr** 1931. Leningrad—Vienna. Fig. 12.
**Bakhchanyan, Vagritch** 1938. Moscow—New York. Fig. 6.
**Belenok, Petr** 1938. Moscow. Figs. 70 and 71.
**Belkin, Anatoly** 1952. Leningrad. Fig. 72.
**Bielutin, Ely** 1924. Moscow. Figs. 2, 9, and 73.
**Borisov, Leonid** 1943. Leningrad. Fig. 74.
**Brui, William** 1946. Leningrad—Paris. Figs. 38, 75, and 76.
**Donskoi, Roshal, and Skersis,** Moscow, Fig. 45.
**Dyshlenko, Yuri** 1936. Leningrad. Fig. 50.
**Elinson, Henry** 1935. Leningrad—Monterey. Fig. 18.
**Esoyan, Sergei** 1935?. Moscow. Fig. 9.
**Gerlovin, Valery** 1945?. Moscow. Figs. 47 and 48.
**Gerlovina, Rima** 1951?. Moscow. Figs. 46, 47, and 48.
**Gorokhovsky, E.** 1942?. Moscow. Fig. 77.
**Gumeniuk, Feodosy** 1941. Leningrad. Fig. 78.
**Infante, Francisco** 1943. Moscow. Figs. 16, 17, and 79.
**Kabakov, Ilya** 1933. Moscow. Fig. 80.
**Kalinin, Viacheslav** 1939. Moscow. Fig. 81.
**Kandaurov, Otari** 1937. Moscow. Fig. 27.
**Kaplan, Anatoly** 1902. Leningrad. Fig. 11.
**Kharitonov, Alexander** 1931. Moscow. Figs. 51 and 82.
**Koleichuk, Viacheslav** 1941. Moscow. Figs. 14 and 15.
**Komar, Vitali** 1943 and **Melamid, Aleksandr** 1945. Moscow. Figs. 5, 41, 42, 43, 44, and 52.
**Kornfeld, Tatiana** 1950. Leningrad—Israel. Fig. 83.
**Krasnopevtsev, Dmitry** 1925. Moscow. Figs. 84, 85, and 86.
**Kropivnitskaya, Valentina** 1924. Moscow. Fig. 8.
**Kropivnitsky, Lev** 1922. Moscow. Fig. 34.
**Kudrashev, Oleg** 1932. Moscow—London. Fig. 87.
**Lapin, Leonhard** 1947. Tallinn. Figs. 24, 25, and 88.
**Leis, Malle** 1940. Tallinn. Figs. 26 and 53.
**Liagachev, Oleg** 1939. Leningrad—Paris. Fig. 20.
**Makarenko, Vladimir** 1943. Tallinn. Fig. 89.
**Masterkova, Lydia** 1931. Moscow—Paris. Figs. 35, 90, 91, and 92.
**Meel, Raul** 1941. Tallinn. Figs. 54 and 93.
**Mikhnov-Voitenko, Evgeny** 1932. Leningrad. Figs. 4, 55, 94, 95, and cover.

**Murin, Ilya** 1943. Leningrad. Figs. 31, 32, and 96.
**Neizvestny, Ernst** 1925. Moscow—New York. Figs. 1, 7, 97, and 98.
**Nemukhin, Vladimir** 1925. Moscow. Figs. 56 and 99.
**Nusberg, Lev** 1937. Moscow—Paris. Fig. 13.
**Ovchinnikov, Vladimir** 1941. Leningrad. Figs. 57 and 100.
**Petrochenkov, Yuri** 1943. Leningrad. Fig. 101.
**Pivovarov, Viktor** 1937. Moscow. Figs. 40, 102, and 103.
**Plavinsky, Dmitry** 1937. Moscow. Figs. 104, 105, 106, and 107.
**Ploomipuu, Urmas** 1940?. Tallinn. Fig. 110.
**Prokofiev, Oleg** 1928. Moscow. Figs. 58, 111, and 112.
**Rapoport, Alek** 1933. Leningrad—San Francisco. Fig. 113.
**Rokhlin, Vladimir** 1937. Leningrad. Fig. 30.
**Ross (Zakharov), Igor** 1945. Leningrad. Figs. 19 and 59.
**Rubashkin, Samuil** 1906 - 1975. Moscow. Figs. 10, 60, and 114.
**Rukhin, Evgeny** 1943 - 1976. Leningrad. Figs. 36, 115, 116, and 117.
**Schiller, Sophie** 1940. Moscow—Boston. Fig. 3.
**Shemyakin, Mikhail** 1943. Leningrad—Paris. Fig. 118.
**Shteinberg, Edward** 1937. Moscow. Figs. 37 and 61.
**Sooster, Ullo** 1924 - 1970. Moscow. Figs. 21 and 119.
**Sveshnikov, Boris** 1927. Moscow. Fig. 62.
**Titov, Vladimir** 1951?. Moscow. Figs. 120 and 121.
**Tiulpanov, Igor** 1939. Leningrad. Figs. 29, 63, and 122.
**Tselkov, Oleg** 1937. Moscow. Figs. 28, 64, and 123.
**Vinkovetsky, Yakov** 1938. Leningrad—Clarksburg. Fig. 124.
**Vint, Mare** 1942. Tallinn. Fig. 126.
**Vint Tonis** 1942. Tallinn. Figs. 22, 23, and 127.
**Vorobiev, Valentin** 1937. Moscow—Paris. Fig. 125.
**Yakovlev, Vladimir** 1934. Moscow. Fig. 33.
**Yankilevsky, Vladimir** 1938. Moscow. Figs. 38, 128, 129, 130, and 131.
**Zeldin, Boris** 1944. Leningrad—Bloomington. Fig. 132.
**Zelenin, Edward** 1938. Vladimir—Paris. Figs. 133 and 136.
**Zharkikh, Yuri** 1938. Leningrad Fig. 65.
**Zhutovsky, Boris** 1932. Moscow. Fig. 66.
**Zilius, Vladas** 1939. Vilnius—New York. Figs. 67 and 137.
**Zverev, Anatoly** 1931. Moscow. Figs. 134 and 135.

# Selected Bibliography

An exhaustive recent bibliography can be found in Igor Golomshtok and Alexander Glezer, *Unofficial Art from the Soviet Union* (London, 1977).

Astrachan, Anthony. "Why Khrushchev's Favorite Sculptor Chose Exile." *New York Times,* April 11, 1976.

*Avant-garde russe, Moscou 1973.* Paris: Galerie Dina Vierny, 1973. Introduction by Dina Vierny.

Berger, John. *Art and Revolution. Ernst Neizvestny and the Role of the Artist in the USSR.* London, 1969.

Borgman, Mikhail, and Rischin, Ruth, et al. *Twelve from the Soviet Underground.* Exhibition catalog. Berkely, California: Judah L. Manges Museum, May, 1976.

*Boris Birger: A Catalogue.* Ann Arbor, 1975. Preface by Heinrich Boll. Introduction by Shirley Glade, Ellendea Proffer.

Bowlt, John E. "Art and Politics and Money: The Moscow Scene." *Art in America,* March-April, 1975.

_____ . "Socialist Realism Then and Now." in Bowlt, *Russian Art 1875-1975: A Collection of Essays.* New York, 1976. (Originally in B. Eissenstat, ed. *The Soviet Union: The Seventies and Beyond.* Lexington, 1975.)

_____ . "The Art of Change." *Journal of Russian Studies.* 1975.

_____ . "The Soviet Art World: Compromise and Confusion." *Art News,* December, 1975.

Catteau, Jacques. "Oscar Rabin, Painter." *Survey* 57, October, 1965.

_____ . *Russian Art of the Avant-Garde: Theory and Criticism, 1902-1934.* New York, 1976.

Chemiakin, Michel. *Saint Petersbourg 71 Avant-Garde Russe,* Paris: Galeria Dina Vierny, 1971.

_____ . *Apollon - 77.* Paris: Les Art Graphiques de Paris, 1977.

*Chroniques de l'art vivant* 23, September, 1971. "L'art avant-garde de l' URSS." Special issue on Soviet avant-garde. Articles by Jane Nicolson and Michel Ragon.

Dodge, Norton T. "Art and Soviet Foreign Relations." (a statement in) *Recent Developments in the Soviet Bloc.* Hearing before the Subcommittee on Europe of the Committee on Foreign Affairs of the House of Representatives, Part I, Washington, D.C., G.P.O., 1964, pp. 52-60.

_____ . *New Art from the Soviet Union: Selected Works on Paper.* Mechanicsville, Maryland: Cremona Foundation, 1976. Catalog for exhibition at annual convention of American Association for the Advancement of Slavic Studies, St. Louis.

_____ . *Ely Bielutin, Sophie Schiller.* St. Mary's College of Maryland Gallery: St. Mary's City, Maryland, 1977.

Etiemble, R. "Pictures from an Exhibition." *Survey* 48, July, 1963. On the Manege exhibition.

*Eugene Rukhin: A Contemporary Russian Artist.* Raleigh, North Carolina: North Carolina Museum of Art, 1975.

Introduction by Moussa M. Domit; biographical note by Ruth Mayfield.

Gardner, Paul. "Art and Politics in Russia." *Art News,* December, 1974.

Glezer, Alexander, compiler. *Iskusstvo pod buldozerom.* London, 1975.

Golomstock, Igor [Golomshtok]. "Paradoxes of the Grenoble Exhibition." *Kontinent 1,* March 1, 1974. On the exhibition *Huit peintres de Moscou.* English version, Garden City, New York, 1976.

_____ . [Golomshtock]. "Unofficial Art in the USSR: The Mechanism of Control." *Studio International,* December, 1974.

_____ . [Golomshtok]. "The Language of Art under Totalitarianism." *Kontinent 7,* 1976.

_____ . [Golomshtok] and Glezer, Alexander. *Unofficial Art from the Soviet Union.* London, 1977. Catalog of exhibition organized by Sir Roland Penrose and Michael Scammell, The Writers and Scholars Educational Trust. Exhaustive bibliography.

Glueck, Grace, "Art Smuggled out of Russia Makes Satire Show Here, " and Shipler, David K., in Moscow, "Impish Artists Twit the State." *New York Times,* February 7, 1976.

_____ . "Dissidence as a Way of Art." *New York Times Magazine,* May 8, 1977.

Hain, Juri, ed. *Eest Graafika, 1910-71.* Tallinn, 1973.

*Huit peintres de Moscou.* Musee de Grenoble, 1974. Preface by Maurice Besset. Anonymous introduction.

Infante, Francisco. "An 'Architecture' of Artificial Systems in Cosmic Space." *The Structurist* 15/16, 1975-76.

Jacoby, Susan, and Astrachan, Anthony. "Breaking Free: Contemporary Art in Russia." *Washington Post,* August 1, 1971.

Johnson, Priscilla and Labedz, Leopold, eds. *Krushchev and the Arts — the Politics of Soviet Culture, 1962-64, Documents.* Cambridge, 1965.

Kaiser, Robert. "Where Quality Is Its Own Reward." *Washington Post,* December 22, 1974.

Kartna, A. *Soviet Estonian Art* (English). Tallinn, 1967.

"Kinetic Performance in Leningrad." *Studio International,* December 1967. On the group "Dvizhenie" (movement).

Korzukhin, Alexei. "Colors and Rainbows: Malle Leis." *Stena* 5, May, 1976.

Kulikova, I. S. *Siurrealizm v iskusstve.* Moscow, 1970.

Lebedev, A. K. *K sporam ob abstraktsionizme v iskusstve.* Moscow, 1970.

Levin, Mai. "Three-Dimensional Art Expression." *Kunst,* No. 42/2, 1972.

Louis, Jennifer. "Oscar Rabin: Soviet Solitary." *Studio International,* June, 1965.

Myers, Diana. *Unofficial Art in the Soviet Union, 1962-1974: A comparison of the Manezh and Ismailova Exhibit.* Unpublished senior thesis, Princeton University, 1976.

Moiseenko, E. "Traditsii i poisk v iskusstve." *Iskusstvo* 4, 1977.

"Moscow Kineticists." *Studio International,* August, 1966.

Nalbandyan, Dmitry. "Falshiviye Tsennosti Abstraktsionizma" (The False Values of Abstractionism). *Ogonek (The Lamp)* 32, August, 1975.

Nathanson, Melvyn B. *Komar/Melamid.* Carbondale (forthcoming).

Newman, Amy. "The Celebrated Artists of the End of the Second Millenium A.D." *Art News,* April, 1976.

Nikulin, Lev. "Art and Pseudo-Art." *Soviet Literature Monthly* (in English). April, 1963.

Nussberg, Lev. "What is Kineticism?" *Form* 4, April 15, 1967.

*La peinture russe contemporaine.* Paris: Palais des Congrès, 1976. Introduction by Alexander Glezer.

*Progressive russische kunst/Lev Nusberg und die Moskauer Gruppe "Bewegung."* Cologne: Galerie Gmurzynska, 1973.

*Progressive Tendencies in Moscow, 1957-1970.* Bochum: Bochum Museum. Introduction by Arsen Pohribny, 1974.

Rubenstein, J. "Refreezing the Thaw." *Art News,* December, 1971.

*The Russian Avant-garde, 1960-1970.* Basel: Galerie Liatowitsch, 1972.

Schroder, Thomas. "Aus Moskou Verjagt: Bilder im Exil." *Zeit Magazin* 13-21, March, 1975.

Seiberlig, Dorothy. "A Russian Life: Tiny Pictures at an Exhibition." *New York Magazine,* February 8, 1976.

Sjeklocha, Paul and Mead, Igor. *Unofficial Art in the Soviet Union.* Berkeley and Los Angeles, 1967.

Stevens, Elisabeth. "Moscow's Artists in Isolation: Still a Struggle to Create." *Washington Post,* October 20, 1974.

Thorez, Paul, ed. "Numero Special sur l'Art Sovietique." *Opus International* 4, December, 1967.

*Tretia Volna* 2, Montgeron, France, 1977.

Valkenier, Elisabeth. *Russian Realist Art, The State and Society: The Peredvizhniki and Their Tradition.* Ann Arbor, 1977.

Vint, Tonis and Ootsing, Enno, eds. *Noorte Kunstnike Grupinaituse Kataloog* Tallinn, 1975.

Vint, Tonis, and Ootsing, Enno, eds. *Noorte Kunstnike Grupinaituse Kataloog,* Tallinn, 1975.

Wright, A. C. "Soviet Art—The Contemporary Scene." *Art Journal* 29, No. 3, Spring, 1970.

Zvontsov, V. "Esli tebe khudozhnik imia." *Leningradskaya Pravda,* October 16, 1975.